MAX
BECKMANN

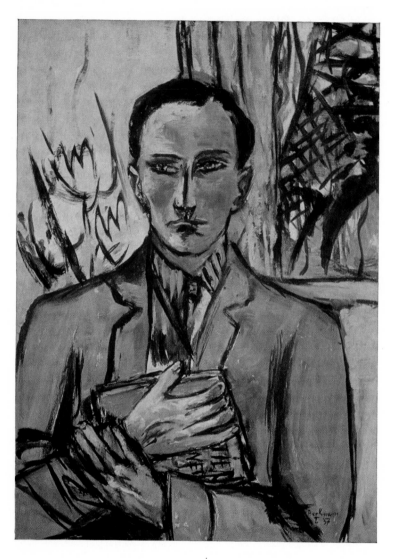

Portrait of Stephan Lackner. Oil. 1937-39

MAX BECKMANN

MEMORIES OF A FRIENDSHIP

By STEPHAN LACKNER

UNIVERSITY OF MIAMI PRESS

Coral Gables, Florida

ILLUSTRATIONS

ACKNOWLEĐGMENTS

I am indebted to Dr. K. F. Bauer of Frankfurt am Main, Mr. Perry Rathbone, Boston, and Dr. A. Melamed, Milwaukee, for permission to reproduce certain illustrations. The other materials are all from the collection of Dr. and Mrs. Stephan Lackner.

I also wish to thank Albert Langen-Georg Müller Verlag, Munich, for permission to quote from Max Beckmann's Diaries, and Prentice-Hall, Inc. for permission to reprint "On My Painting."

Many thanks are due to Mrs. Mathilde Q. Beckmann for her interest and help, and for establishing the definite text of her late husband's London speech.

MAX
BECKMANN

I n the spring of 1933, a few months after the Nazis had come to power, my older brother and I traveled by car through the small German town of Erfurt. We noticed some posters: MAX BECKMANN EXHIBITION. "These people have guts," said my brother and drove to the museum.

However, when we reached the entrance, it was locked. Red strips of paper proclaiming "Postponed" were pasted across the exhibition posters. We went into the museum's office where some officials were engaged in a lively and apparently not altogether happy discussion. The new National-Socialist regime had just forbidden them to show the work of this prominent German expressionist. The term "degenerate art," which up to then had been used mostly by retrograde cranks, had suddenly become the guideline for the cultural life of the German nation.

We asked whether the paintings had arrived.

"Yes, they are standing in the basement, but the public is not allowed to see them."

"We are personal friends of Professor Beckmann, and we made a long detour especially to view his pictures." We really knew Beckmann only slightly, but the fib worked. A curator led us into the museum basement.

And there I received what turned out to be the most decisive impression of my life.

Beckmann's art had literally gone underground. Perhaps a feeling of foreboding, even of danger, augmented the impact. The catacomb-like darkness was pierced by a single light bulb dangling from the ceiling. Fleeting visions stormed in on us: strong, proud figures in landscapes glittering like jeweled mosaics. The richness of these new works was overwhelming. Where was the bitter irony, the scathing caricature, the almost clinically cool dissection of man's cruelty which, to many observers, had been Beckmann's trademark? These beings seemed to have broken through to a renewed self-respect; they were individuals striving to master their fate. It was a silent, sublimated protest against the massed forces of oppression and uniformity that, above ground, gained daily victories over Hitler's remaining enemies.

The most striking innovation was a new feeling for the nude. When Beckmann's earlier pictures had shown nakedness, it was

11

symbolic of poverty, deprivation, persecution, or of stark eroticism. All that had changed: these nudes seemed descended from preclassical myths. They did not literally illustrate antique fables; and yet, Ulysses was there, listening to the sirens' song, bound to his ship's mast. Adam and Eve glistened in primeval innocence. This was not a return to the pale classicism of the nineteenth century; the contours were charged with expressionist high tension, the dynamic colors flickered on the viewer's retina. Some figures seemed bathed in the pure, thin, luminous air of prehistory. The painter looked right through the confusion of our present-day troubles and saw the shimmer of distant hope above the horizon. An almost hypnotic consolation emanated from those canvases.

And this tremendously important art should now be "verboten"?

I inquired immediately of the artist in Berlin whether I could buy his painting "Man and Woman." From a practical point this was crazy. It was a huge picture. I had no place in the world where to hang it; my parents had just emigrated to Paris, and I myself was finishing my studies at a German university and planned to leave without quite knowing where to go. Still, I had the feeling that the power of this work of art would steer my life into new channels.

Beckmann's answer came on June 21, 1933. He agreed to sell and added, "I was delighted to find that a young man has the courage and energy to realize his own feelings."

A little later, when I visited Beckmann in Berlin, he told me that he had been deeply depressed by the interdiction of his art, and that my offer had been the only sign of sympathy to reach him on that fateful day. "I will never forget your beau geste!" We remained friends from then on.

I had met Beckmann four or five years earlier in Frankfurt am Main. I was a young student, twenty-six years his junior, and he was a much-discussed and widely acknowledged master.

Frankfurt around 1928 was a good place to get involved with

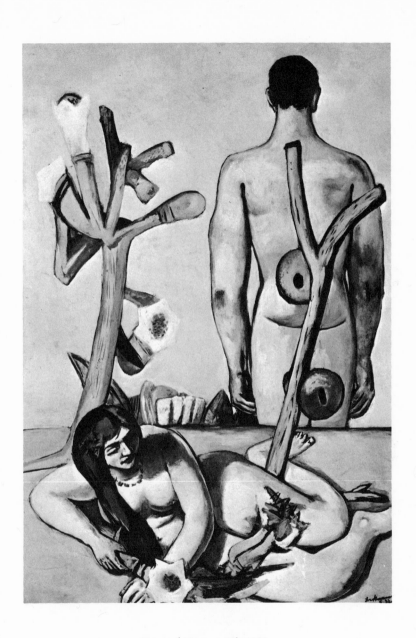

Man and Woman. Oil. 1932

expressionism. There was excitement in the air whenever this new art was talked or written about, and each new exhibition was an exhilarating and sometimes flabbergasting event. A youngster who had walked through a number of museums could have the definite feeling: Art has just sprung alive! This was a sort of hubris, and it was destined to come to an early end, together with the ill-fated Weimar Republic. But while it lasted, the art of the nineteen-twenties seemed like a period of limitless possibilities, of a tremendous upswing of creativity.

Beckmann, born in Leipzig in 1884, was part of the generation which produced Klee, Kirchner and Kokoschka, Otto Mueller, Schmidt-Rottluff, Marc and Macke, Grosz and Dix, the sculptors Barlach and Lehmbruck, the *Bauhaus* artists and so forth—an overwhelming array of new talent which, to German eyes, appeared fully as important as the contemporary School of Paris. They had striven for complete liberation of their artistic means, and a good part of the public was willing to absorb the shock waves emanating from these explosive fireworks of expression. Beckmann, though not a member of groups like the *Blaue Reiter, Brücke,* or *Bauhaus,* seemed to "belong."

He benefited from the open-mindedness of the people who shaped the cultural life of Weimar Germany. Many museums were acquiring his paintings, and the Berlin National Gallery had a special room dedicated to his work. As a professor at the Städel Academy in Frankfurt he was venerated by his pupils. He was lionized by literary circles and by Frankfurt's "high society."

This last fact was rather curious, for Beckmann was not a comfortable man to have around. During World War I and its aftermath, the inflation period, he was one of the harshest critics of the economic and moral depression. His brush was at its best when dipped in gall and vinegar. As a German medic in Poland and Flanders in 1914 and 1915, he had been exposed to the horrors of battlefield and hospital. Consequently, tortured victims of man's inhumanity to man had become his main subject. He was never as direct in his social criticism as, say, George Grosz. Some enigmatic pictorial beauty still prevailed in his etchings and canvases filled with maimed bodies, pimps and prostitutes, shabby carnival scenes, and nocturnal crimes. As

14

times became more prosperous, his palette grew lighter and his themes gayer. Yet, to tell the truth, at this period I personally was still somewhat repulsed by the irony that prevailed in his graphics and paintings. They were not the stuff to inspire confidence in an idealistic youth.

When I first saw the man, I was overwhelmed and a little scared. That I became better acquainted with him was perhaps due to a curious predilection of his: Beckmann considered human company as raw material for his compositions. A party, to please him, had to be composed in a certain way. He liked sharply defined, widely divergent types. He was most interested when a room contained one old-fashioned, debonair aristocrat; two or three spectacularly beautiful women, preferably one blonde, one dark-haired; some businesslike, energetic bourgeois; a vivacious, swarthy, and somewhat mysterious art dealer; and several slim, intellectual, adoring youngsters. I must have fitted into this last category, as did my friend, the composer Bernhard Heiden in whose parental home I was first introduced to Professor Beckmann. In my memory those parties appear uncannily like live Beckmann paintings.

He himself certainly looked like his self-portraits: a more than life-size figure with a massive rocklike head reminiscent of an archaic idol, an athletic, well-shaped body which, at that time, was clothed with easy elegance. He visibly enjoyed confusing people with his sharp, deliberately banal witticisms growled in Berlin dialect. I soon discovered that his cynical front was a protective armor to shield the difficult, labile process of creation that constantly went on in his mind. His aura of uncompromising integrity was what captured me, but I did not think that we could give much to each other. Also, the quarter of a century which separated us seemed an unbridgeable gap. Later, as that fraction of life's total receded in perspective, the distance between us shrank considerably.

All my mental reservations vanished when Beckmann became the object of Nazi persecutions. Objectively, he could not possibly be defined as un-German or as an enemy of the state. Politically he was not active at all; racially he was descended from Low Saxon stock. To me he was living proof that Hitler's theories

15

were nothing but window dressing, that the Nazis were insincere in their proclaimed "purification" endeavors, that they simply wanted to get rid of everybody who did not glorify the Führer.

In April, 1934, I acquired my second Beckmann painting, "Brother and Sister." By now the artist had become a lonely man. In 1933 he had lost his teaching job at the Städel Academy in Frankfurt. He had moved to Berlin; the big city seemed to offer more anonymity and protection than Frankfurt, where he had been a prominent figure. The pioneering Jewish art dealers were leaving Germany. Few collectors still dared to buy "degenerate art." I visited Beckmann and his charming wife several times in their old-fashioned but tastefully furnished apartment near the Tiergarten. On my birthday they invited me for tea, and suddenly Beckmann lifted a large folder out of a drawer. "Now, my dear boy—select a watercolor as a birthday gift." After some hesitation I chose a portrait of Quappi, his wife, sitting at a restaurant table with oysters and a glass of red wine; a view of the calm sea made this a joyous picture.

"But I thought that I—" Mrs. Beckmann said, somewhat surprised.

"What I promised, I promised!" With a sweeping gesture he handed me the watercolor and insisted that I accept it. I am sure that Quappi has since forgiven me.

I was inordinately proud of my collection of three Beckmanns and regretted only that I could not show off to anybody in Germany. I had Beckmann ship them to my parents in Paris.

Often in former years I had studied the six or eight Beckmann paintings that filled an exhibition room in the Kronprinzenpalais, the official modern museum of Berlin. When I returned to review these with my somewhat matured knowledge, I found that the very avant-garde "Barge" had been replaced by a cowshed interior with three ruminants—a tame picture, but still a Beckmann. A well-meaning curator had exchanged the two paintings. The "Barge" had shown a beach scene with lusty bathers, expressionistically distorted, and the good curator had supposed that the brown cows might be acceptable to the brown-shirted Nazis who glorified *Blut und Boden* (blood and soil, a strangely perverted, simplistic folk art). The trick did not help for long; soon every

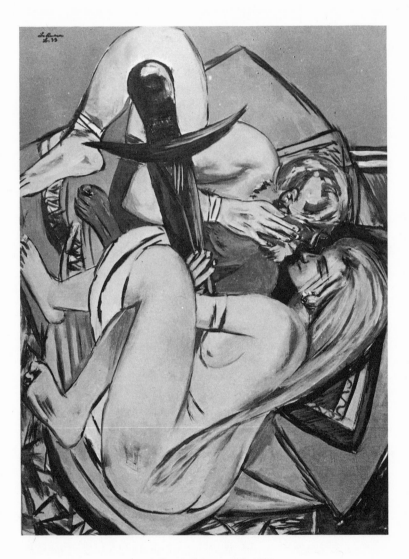

Brother and Sister. Oil. 1933

work by Beckmann was eliminated from the national museums.

Max Beckmann still would not believe that the German people were willing to follow the Führer all the way. He joked bitterly about the "Verführer," the misleader or seducer. He felt beholden to old Germany but he never was a chauvinistic nationalist. His experiences as a medic in World War I had given him a lasting hatred for militarism that he often expressed in his art: a point which did not ingratiate him with the Nazi party. Another point of disagreement with the new state was his fierce individualism—his almost physical need to be free, his disgust for any regimentation. Still, basically he felt himself to be part of a wider Germanic culture. In 1917 he had declared his adherence to "the four painters of masculine mysticism: Maeleszkirchener, Grünewald, Brueghel, and van Gogh," and he always remained faithful to this Nordic *Weltanschauung*. In 1923 the influential critic Curt Glaser wrote: "Whoever has learned to read the singular beauty in the hard language of the old German masters will have an easier access to Beckmann. He is, in one word, a German painter."

Now suddenly, he was redefined as un-German, a label that was even considerably more dangerous than the "un-American" bugaboo during the fifties in this country. The trend had shown itself in 1932 when the National-Socialist writer Bettina Feistel had seen in Beckmann's work "nothing but fakement, grimace, intellectualism." The tone and scope of these indictments became ever more menacing until, in 1938, Dr. Adolf Dresler declared in his standard work, *German Art and Degenerate Art,* "There is hardly a single work of the *Kunstbolschewist* Beckmann which is not a base obscenity." Needless to say, Beckmann never was a bolshevik. But the Nazis were not choosy in their accusations when they were out to destroy a man.

For Beckmann this persecution was especially hard to bear because success had come to him very early in life. Born in 1884, he was admitted to the Weimar Academy in 1900. In 1906 he received the important Villa Romana prize, which carried a stipend for half a year's study in Florence. In 1910 he was elected

to the directors' board of the Berlin "Secession," a famous artists' association.

In 1913, when he was only twenty-nine years old, the first monograph on his art appeared, with forty-two illustrations—a quite unusual honor for such a young painter. The author, Hans Kaiser, went overboard with admiration for Beckmann's then still rather impressionistic art. He attested to him "the highest spirituality combined with highest realism. The colors seem to open up like flowers to reveal their secrets . . . The progress of his paintings of the last years is due to an energetic concentration which sacrifices everything to the work, until the artist is utterly exhausted. This makes Beckmann's works unique beyond his own generation." About Beckmann's "Drama," which was painted in 1906, Kaiser wrote, "With this 'Drama' he becomes the expressionist of inner experiences."

The high point of the painter's early career was the appearance, in 1924, of a luxurious volume containing fifty-two large illustrations; four of the most influential and progressive German art critics combined their forces to comment on Max Beckmann's art. Curt Glaser, for instance, wrote: "This is the rhythm of today's life, these are the stimuli to which the nerves of modern, americanized cosmopolitans are exposed. To have captured the shrillness of our amusement park, figuratively and symbolically, that is Beckmann's accomplishment. This new beauty has been embodied in his art . . . Transcending all the cruelty, new rhythms swing through clean landscapes, sounding the harmony of pure lines." And Wilhelm Fraenger analyzed: "I wish to define the severe organizing principle of his form as a visual manifestation of the idea of justice: the rational, logical system of his own creation is superimposed over the confused, depraved world, transforming it into a world of color as it should be . . . Beckmann is the Hogarth of our epoch!" All four writers were somewhat disturbed by Beckmann's crude motives, especially by his cripples, prostitutes, and robber barons. Meier-Graefe was the most critical: "Sometimes he resembles a garbage disposal worker, but, what the devil, the future is his." Yet Wilhelm Hausenstein acknowledged: "The beauty of his colors amounts to an idolatric cult, to a sanctification of things as

19

they are. The construction of his compositions also is part of this beauty, and one can understand that Beckmann is convinced of having painted beautiful pictures."

These essays were, in spite of their authors' reservations, thoroughly intelligent comments that were also carried over into discussions in newspapers and magazines. Beckmann was "news." By contrast, his fiftieth birthday—February 12, 1934—passed without a single mention of his name in the German press.

What I had encountered first in the basement of the Erfurt museum, that catacomb-like atmosphere with unheard echoes among menacing shadows, became the mood of Beckmann's existence. His art, which should have communicated the joy of creativeness, had become something to be shunned. Probably the only art dealer who dared exhibit his works in a back room was Günther Franke in Munich. The museums banned his paintings. Personally he still remained relatively unmolested: the Nazi regime at first persecuted mostly Communists, Socialists, and Jews, and Beckmann did not fall into these categories. But many of his friends had departed from the inhospitable Reich; others pretended not to know him any more. Silence surrounded the erstwhile celebrity.

I went to Paris, the city of my birth. In 1935 I started writing essays on cultural subjects for a German-language, anti-Nazi weekly, *Das Neue Tage-Buch*, which was edited and printed in Paris. Emigré papers in Prague, Paris, Basel, and other cities published my articles and stories, and the German government attested to their effectiveness by depriving me of my citizenship. To avoid harming my friend Beckmann, I hardly corresponded with him any more.

Meanwhile, in Germany the conditions for modern art grew worse. There were still some discussions; there even was some courageous opposition to the former housepainter's taste, which had become the canon of German artistic life. Max Liebermann, the grand old man of German impressionism, was kicked out of the presidency of the Prussian Academy and said: "I couldn't

possibly eat as much as I would like to puke." This bon mot was widely circulated at the time. Many artists left Germany: Klee went to his native Switzerland, where Kirchner also found refuge, Kokoschka emigrated to England, George Grosz and Feininger to America. The museums were ordered to get rid of their "degenerate art," which meant expressionism, cubism, constructivism, surrealism, abstract art—in short, everything which did not further the ideals of a blond, unintellectual warrior race. The newly installed director of the Essen Museum, Count Baudissin, declared that "the greatest work of art is the German soldier's steel helmet."

Alfred Rosenberg, who later became *Reichsminister* and finally was hanged after the Nürnberg trials, had written the most influential book about cultural matters in the Nazi sense; first printed in 1930, it had sold 663,000 copies by 1938. Some excerpts from Rosenberg's *Myth of the Twentieth Century* will show why artists such as Beckmann could not get along with National Socialism, and vice versa. "The night coffee houses of the asphalt city became the artists' studios. Theoretical, bastardized dialectics became the prayer wheel whose whining accompanied ever new -isms. The racial chaos of Germans, Jews, unnatural mongrel breeds of the street became prevalent. The consequence was the rule of the Mestizo. The Mestizo claimed to represent his 'soul expression' in bastard stillbirths, caused by spiritual syphilis and painterly infantilism. . . . One has only to look long and attentively at the self-portraits of Kokoschka in order to understand the gruesome inner life behind this idiot art. The same applies to our 'European spirit' which glorifies, through Jewish pens, the Kokoschkas, Chagalls, Pechsteins as leaders of the art of the future."

The propaganda minister, Joseph Goebbels, fulminated against *Bordellkunst,* the art of the brothel. He simply mistook the motif for the message. Does Hogarth glorify vice in "The Rake's Progress"? Does Holbein, in his "Dance of Death," join the party of the ghostly skeleton? Many graphic artists after World War I, men like Otto Dix, George Grosz, and Beckmann, insisted on showing whores and pimps, thieves and beggars, all kinds of perversions and depravity. Did that mean that they themselves were depraved? The Nazis thought so.

21

It struck me as a strange paradox that Beckmann, at the time of these attacks, had already abandoned those themes. His field of interest has shifted from social criticism, from the twilight flickering above the asphalt jungle, to mystical ideas that he sometimes symbolized in quasi-classical nudes.

We can discern two kinds of nudity all through the history of art: underprivileged nudes and nudes expressing abundance. Christ crucified belongs to the first kind, and Beckmann had painted and etched that emaciated figure many times from 1910 to 1917. This category also comprises his studies from brothels in Flanders, which he had observed as a medical corpsman in 1915, and the torture chamber in "The Night" of 1918-1919. The second category, nakedness from an overabundance of bodily health and beauty, came to the fore with his "Man and Woman" of 1932. His earlier nudes had shown his pity for abused human beings, albeit in an unsentimental, hard-boiled style. Many of those pictures around 1920 have the strict composition of a crystal—Beckmann's personal variant of cubism—but those crystals are full of internal tension and torsion; their regularity cannot hide the deep splits and cracks that are symptomatic of the artist's own inner struggle. All this changed in the thirties. His nudes now represented superior beings, demigods, proud individuals, reflections from antiquity. Beckmann's human creatures became whole and sound. They are animated by an ardent will to live in freedom, and some have a strangely touching, youthful beauty.

Before condemning Beckmann as decadent and un-German, the Nazis might profitably have looked at these, his latest works. "Brother and Sister," for instance, presents two definitely Germanic types who vaguely correspond to Siegmund and Sieglinde of the ancient Nibelung epics. Both have luxuriant blond manes, reminding one of Nietzsche's idealized "blond beast." Alfred Rosenberg, the Party philosopher, had burrowed his way through all of Dante's writings and, finding exactly three mentions of blond hair therein, had claimed the "Nordic" Dante as a spiritual ancestor of Nazism. Somebody with this *idée fixe* might easily have drawn wrong conclusions from Beckmann's Nordic types, especially from the radiant, golden-blond little boy

in the exact center of his triptych "Departure." But, perhaps luckily, the Nazis were too constricted in their dislike of expressionist form to claim Beckmann as their own. This whole speculation, however, is not too far of the mark. The excellent painter Emil Nolde, blond descendent of North German peasants, applied for membership in the Nazi party: he thought quite naively that he was predestined to become the acknowledged master of Aryan art. The Nazis only jeered at him, threw his pictures out of the museums, and forbade him to paint! Beckmann, thanks to his hatred against militarism and against the "ant state" in every form, was immune. He worked and waited.

From 1932 to 1935 he painted the huge, fascinating triptych "Departure," its aristocratic individuals detaching themselves from the cruelty and confusion of actuality. The theme of this work seems a distinct premonition of his own destiny: the destiny of becoming a homeless wanderer.

In the fall of 1936, Max Beckmann suddenly appeared in Paris. He told my parents and me that he could not go on much longer: the pressure inside Germany was insupportable; the Nazis crushed all opposition; they did not even tolerate the standing apart of neutral individuals. Every facet of life was subordinated to rearmament, hatred of everything foreign was rampant, and true art had ceased to be a factor in Germany's *Kultur.* A new solution to his own problems had to be found, in the interest of his creativity.

My father, a clear-thinking and well-meaning industrialist, did not yet have a warm relationship with Beckmann's "wild" art, but he felt that here was a tremendously important personality. He assured Beckmann of his financial backing should the artist decide to emigrate from Naziland. My mother suffered considerably from homesickness; still she encouraged Herr Professor Beckmann by quoting August von Platen, her favorite nineteenth-century romantic poet: "Far better it is to renounce the fatherland than, subject to a worthless breed, bear the blind hatred of the mob." Some Parisian friends were consulted; the

consensus was that an eventual emigration to the United States might be preferable to the uncertainties of Europe. Yet none of the various plans materialized.

However, I proposed a modest first step which seemed practicable. I asked Beckmann to illustrate a book for me. He had read and liked my drama "Der Mensch ist kein Haustier." ("Man is Not a Domesticated Animal" would be a literal translation, but the title sounds more like a proverb in German; "Man Undomesticated" might be closer.) Beckmann was willing to make several lithographs for this projected book. I promised to pay his fee outside Germany; since the monetary restrictions for Germans were becoming more and more stringent, this was important in case Beckmann should decide to leave the Reich. Beckmann gave me some advice, for which I was grateful, about rewriting parts of my play; I already considered myself his pupil. A little more optimistic, he returned to Berlin.

I kept contact with Beckmann through a fashion magazine reporter, Kati von Porada, who had official permission to travel back and forth to inform German readers about Paris *haute couture.* Beckmann had portrayed her in 1924 as a mild, gothically elongated aesthete. I suspect that she was somewhat smitten by his gruff masculinity. Anyway, she remained one of his faithful helpers, and she now went about preparing her friends in the Paris art world for Beckmann's eventual emigration.

Many "people of good will" predicted that Hitler could not stay in power much longer, that the rearming Third Reich would soon be bankrupt, or that the radicalism of the Nazis would play itself out and give way to moderation. However, the National Socialists knew exactly what they wanted, and they consolidated their power with one-track efficiency. Goebbels had acquired control over German culture with the law of September 22, 1933, that established the *Reichskulturkammer:* membership in this body became obligatory for all artists, writers, musicians, and film makers. Those to whom membership was denied were left to change their professions or to starve; many preferred the latter. All exhibitions required permits. Artists' associations were either dissolved or merged with the *Reichskulturkammer.* In November, 1935, the president of the *Kunstkammer* declared that the new

24

Giel and Louise. Lithograph. From "Man Undomesticated." 1938

order prevailed everywhere and that the artist must serve the State only. The Kronprinzenpalais, the modern part of the National Gallery, was closed, and its director, Eberhard Hanfstaengl, was dismissed. Hanfstaengl advised Beckmann to emigrate, saying, "This is only the beginning of the avalanche."

On July 18, 1937, Hitler opened the newly-built *Haus der Deutschen Kunst* in Munich with a programmatic speech that I heard over the radio in Paris. I thought, "Beckmann will not be able to stand this any longer." The Führer spouted hatred against artists "who see our people only as decadent cretins, who, by principle, register meadows blue, skies green, clouds sulphuric yellow." He ordered his Minister of the Interior "to prevent at least the further hereditary propagation of these gruesome optical disturbances." This meant that an expressionist might soon have the choice between castration and leaving his fatherland.

One day after this Hitler speech—and exactly one week before the opening of the Munich exhibition of "degenerate art"—Mr. and Mrs. Beckmann put summer clothes and some personal belongings into a few bags and traveled to Holland, where Mrs. Beckmann's sister, who was married to a Dutchman, lived. Did the fifty-three year old artist have an inkling that he was never again to set foot on German soil?

From Amsterdam, Beckmann wrote me on August 4, 1937, complaining about the bureaucratic difficulties connected with his change of domicile. But he was happy to have found a studio and eager to concentrate on his work. "Your drama pleased me very much," he continued. "I would have liked to talk over the design of the book in greater detail, including the illustrations, but you will work it out all right, and about some things like the cover etc. we can still speak later. Concerning the illustrations: they might emerge very fast, but often I destroy a lot to make it still better, so that this might also take somewhat longer . . . Please don't hurry me, I don't want to work under stress, I want to wait quietly for the moment when I really have something to say. After all, you would not be well served with something

Farewell. Lithograph. From "Man Undomesticated." 1938

scribbled down in a rush. I was surprised to find much in your drama which indicates our shared ideas and thoughts. What a strange affinity of mental states ..."

The text of our book, *Der Mensch ist kein Haustier,* was printed in the same shop as the refugee magazine on which I worked. Beckmann soon sent us his seven lithographic drawings. The play agreed so well with his own ideas that he transformed my main character into his self-portrait. Since 1928 he had created nothing in this graphic medium; the technique appealed to him while his painter's studio was being readied to suit his needs. I was delighted with the spacious spirit expressed in these small works of art. The eternal ocean, skyscrapers, primeval forests, the mechanized mill of civilization, erotic fantasies: Beckmann's inner cosmos, it seemed to me, was formulated in these lithographs.

Beckmann wrote me on August 31, 1937: "Thank you very much for sending the proofs of the lithos. They turned out so beautifully that I am very pleased. There is no need for retouching them, everything seems to proceed very well. I'll be glad to sign the twenty planned copies on Japon-Impérial.— I am happy that you have good news from Buchholz and Valentin. My lawyer wrote me that the paintings will leave Berlin probably end of this week; they will then arrive here three days later, and I shall urgently need a larger sum of money to pay for furniture transport, apartment and studio rent. Otherwise I won't be able to receive the shipment."

In September, 1937, Beckmann came to Paris. He was in a depressed mood, but as soon as I indicated that I would stick to my promise of buying further paintings from him he seemed to revive. He even developed a certain trader's toughness. I still have the slips of paper on which we both scribbled our lists of desiderata, titles of paintings, and proposed prices. We finally agreed on an even dozen, which I selected for the most part from photographs only. The tremendous triptych "Temptation" was among these acquisitions. Most of my acquaintances thought I had lost my mind, and I admit that I felt a little dizzy from the adventurousness of this transaction. I have never regretted it during the long, hard years when Beckmann's art was despised and rejected.

28

The next day we made a kind of pilgrimage to the shop of *Maître-Imprimeur* Desjobert, who produced the prints of Maillol and other famous Parisian artists. He developed a true understanding of Beckmann's special style. When the edition on the finest Japanese paper was finished, Beckmann sat down to affix his signature to one hundred and forty lithographs. When I proposed a pause, he said: "I enjoy this. I feel like a business tycoon signing deals."

An unsigned edition was printed for bookstores in Switzerland and Austria; the German market was, of course, closed to us. We got some good reviews, but not many buyers, in spite of the modest price. Sometimes nowadays I find the book listed in catalogues of rare book dealers, priced a hundred times as high.

Anyway, at the time it was an almost mystical experience for me to be united to the master's spirit between two book covers.

Beckmann's appearance was incredibly impressive. Above his athletic, massive body his large head loomed like one of those rocks left by a prehistoric glacier on top of a hill. While this round, apparently self-sufficient head was sometimes encapsuled by an eery, frozen melancholia, his body looked like a healthy piece of nature. He could portray himself quite realistically in modern bathing dress, his half-nude body seen not as a classicistic study but as the physique of a metropolitan creature who had left civilization for a short while to relax in the sun. At the beach in Bandol, in the south of France, where we spent some weeks together, one could observe what a strong attraction this mature man had for the opposite sex. His mighty vitality flowed not only into his art but also into his daily living.

He loved the full life. All aspects of reality were important to him. To select a meal from a menu absorbed his whole attention; with care and good taste he composed a dinner. To choose the right wine for a friendly gathering was very important to him, and he was a cultured gourmet. "Is there anything better than a good cigar?" he asked at the end of a meal. The lack of tobacco in Amsterdam during and shortly after the war was quite painful to him, and he begged his American friends in almost every letter to

29

send him cigars. I remember one of our last meetings, in the lobby of the Plaza in New York. He hailed the cigarette girl and asked ponderously for a certain outlandish brand of cigarettes. When she could not supply this, he ordered her to carry the brand from now on. "Very important!" he told her. Very important to him were many facets of everyday life, even while his spirit roamed through millennia. Of course he could do without these small luxuries when bad times required it; but he saw himself as a cultivated *grand bourgeois* with aristocratic penchants, and he did not like this picture to suffer. This might seem strange if you think of his scenes of torture and suffering. But a pleasant existence was, as a launching pad for his flights of fancy, "very important."

He dressed with a solid elegance that gave no hint of his artistic profession. In Germany he often wore a stiff black derby, but this did not make him look British, as it would do nowadays; rather, it gave him the flair of a Brechtian stage character. When he wore his black bowler on the streets of Paris, people turned their heads after this exotic figure. One afternoon we had a *Kaffeeklatsch* in my parents' garden near Paris. Suddenly he walked out on the lawn, pulled his derby a little more firmly down on his head, and did several cartwheels, whirling sideways on stiff arms and legs, without losing his hat. We all laughed and applauded. Completely deadpan, he said to me, "Can you do cartwheels? You should learn this too. Very important."

We talked about his new works, and my father made some prosaic remarks. But in Beckmann's presence one just could not make banal conversation for long, and shedding his usual sobriety, my father asked, "Tell me, Mr. Beckmann, have you always looked so terribly impressive? Or are your looks also the result of your own artistic endeavors?"

Beckmann, at first taken aback, replied nicely, "You know, all aspects of the world of phenomena are the product of our own spirit. Including the ego." My father nodded, momentarily convinced.

Even when Beckmann wanted to behave in an obliging, civilized way, he sometimes frightened people. His eyes, light-blue and clear as water with very small, sharp pupils, seemed to penetrate you. He seldom smiled; in all his self-portraits, there is

30

hardly a flicker of a smile. He painted himself somber, thoughtful, critically observing, grim, even a bit arrogant. He probably did more self-portraits than any other major artist since Rembrandt: only on one of them is he laughing, and this, characteristically enough, shows him holding a Berlin newspaper which had just published a nasty review of his art. This was in 1910, and afterwards even that sarcastic grin vanished for forty years. While he was painting his "Self Portrait with the Horn" in 1938, there appeared a dreamy, entranced smile which delighted me when I saw it in his studio; alas, one day he had changed his mien on the canvas almost to one of bitterness. The end result, today, appears to me as one of the most earnest, most philosophical of his paintings; at that moment, long ago, I was somewhat disappointed.

His wife Quappi was the only one who really could make him smile. She had a charming way of entertaining the people around him. When he appeared too glum, she sometimes imitated bird songs with a twittering, high soprano; or, clicking her tongue, she produced the sounds of a horse and buggy. Then he laughed: a smoky, subdued laugh, unexpectedly high, incongruously emerging from his stately body.

To round out the picture, here are some of Beckmann's characteristic remarks which I jotted down immediately after our conversations, between 1934 and 1939.

Basically, my thing originates in an almost demented mirth, but then it aims at not leaving out anything.

My paintings are a kind of medicine through inurement and delight. They really are somewhat heroic. They are not a sedative but a tonic.

You should not use my art like an easy chair but like a breath of fresh air. It should make you trust in an all-comprehensive continuity.

In spite of the general tragedy one has to rely on the infinite justice in all things.

To create a new mythology from present-day life: that's my meaning.

Smuttiness—that really means taking only halfway measures.

Black and white: we cannot do without both, because otherwise we would have banality.

I want to constitute space anew by realizing it inside the plane. Sensuality is most important; I don't want much metaphysical significance.

You should consider mortal danger as an agreeable titillation, and love as an especially valuable pastime. Not more than that. Always keep your eyes fixed on the main thing, on the lodestar. Freedom and justice are indeed ideas which merit a try at realization.

Probably Beckmann had a little secret fun with my Boswellian attitude. As a conclusion to a ponderous conversation he was wont to produce a fake profundity, such as: "Yes, that's the way one has struggled through this diversified life."

In spite of his occasional penchant for scurrilous bosh, many of his utterances opened up surprising perspectives. The rest was only mimicry.

Because his appearance was so imposing, he tried to dissimilate the aura of the *Meister*. With some close acquaintances, even when he obviously had a good time, he hardly talked at all. "Tya tya," a mixed sound between the word yes, a sigh, and clicking his tongue, was his only response between long pauses. His friends did not mind when he was in a taciturn mood. They knew that to him the world had a deep meaning, so deep that it could not be verbalized.

But it could be painted. It had to be painted by him.

Sometimes, sitting in a sidewalk cafe with him, or driving him along the seashore between grotesque rock formations, one could sense this metaphysical Doppler effect in his receptive system: then one knew that the sudden double meaning of this particular scene would, some day soon, reappear on his canvas.

Even though he pretended to be part of the "passing show," he remained basically an observer, an outsider. This had a philosophical basis. He did not feel his ego to be one among several billion personal egos. What he felt, perceived, thought, was the feeling, the perception, the thinking of the world soul, the *Weltseele*. The ego was the only phenomenon identical with its

32

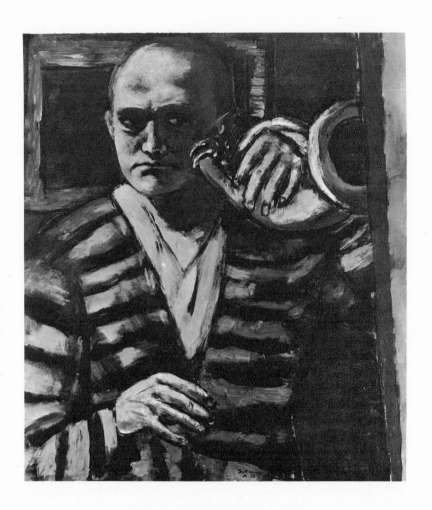

Self-portrait with the Horn. Oil. 1938

own essence: the ego was, for Beckmann, the *Ding an sich,* experienced directly, without the circuitous interposition of senses and rational computation. The ego was palpably there, and the world was its contents.

This almost solipsistic conviction gave him the right to be proud and sometimes even selfish. The "passing show" was an unreal phantasmagoria whose very existence depended on Mr. Beckmann. We mustn't forget that Beckmann was not a philosopher, but a painter, and that his task was not to crystallize his thoughts into a logical system but into pictorial compositions. His experimental solipsism was not a dogma—its conviction fluctuated; some days it was overwhelmingly strong, and then it waned again even to a point of helplessness in dealing with the multiple forces of the world. His diary shows this ebb and flow, and some of his letters to his only son Peter bring it out most clearly. When he tried to think through to a divine principle, he became convinced that God required him, the painter Max Beckmann, to make the creation real. "Yes, He needs me too! " he confessed, with a certain pride. He called God "the Chief," and a secretive, conspiratorial smile played around the corners of his mouth while he pursued such speculations.

The identification of his self with the whole world had some rather surprising side effects. One day we strolled through the Musée de l'Homme, the Paris ethnological museum, and he inspected a huge stone idol from Easter Island whose profile bore a striking resemblance to Beckmann's lapidary features. In walking on, he nodded to the rocky head and remarked casually: "This is what I also was, long ago." And it sounded plausible at the moment.

The solutions and certainties of school philosophy remained foreign to him; his world view was constantly attacked by doubts, like a copper plate eaten by etching acid. He worked over this plate of his consciousness again and again, trying, as he said, to realize a fourth dimension. What the senses offered was not enough, he wanted and needed depth. The flat picture of everyday life appeared too absurd—the overthrowing of legitimate governments, the bombing of perfectly good human dwellings, unemployment of millions when there was so much to be done,

the petty restrictions, and, simultaneously, the thundering stride of world history over the crust of the earth—all this was too meaningless to be more than a spook, a projection of some infernal *Laterna magica*. Then the world of our senses appeared to him as a giant curtain behind which unknown spirits acted out their own projects, and sometimes he thought he could hear peals of their ironic laughter. But the next day he would perhaps cling again to our common reality with all the fibers of his being, and the enjoyment of the offerings of the senses seemed to him the only way to avoid madness.

One might object that the mental speculations of an artist are his own business. This is correct if such thoughts remain private; in Beckmann's case, however, they are reflected in many of his more ambitious works. His triptychs, for instance, can be more readily understood if the beholder has a smattering of Beckmann's vocabulary, his symbols, and his convictions.

The importance of these cross-references between thought and picture is most obvious in his self-portraits. If one knows about the metaphysical importance which the concept of ego had for this artist, one will not suspect vanity or self-glorification as motives for these sometimes terribly egocentric representations. And one will then be inclined to receive their overwhelming spiritual emanation: they were supposed to stand for the world soul.

In a very literal sense one should accept these portraits of the self at face value.

When I acquired Beckmann's "Self-portrait with the Horn" in February, 1939, I felt its aura almost as a natural phenomenon. The pigments—corrected, diluted, painted over many times—have become something that has grown organically: a piece of nature.

The man who looks at you out of this picture seems to listen to an echo: he just has sent a strong and sweet tone from his horn into the distance, now he harkens for a response. He fears that no echo is forthcoming, that he is alone with his private melody.

Initially I had been surprised that Beckmann used such a highly romantic prop as the hunter's horn to symbolize his own existence. Romanticism had been "out" in the Roaring Twenties, and if Beckmann needed noise-makers in pictures of those times,

he chose the funnel of a gramophone, a clown's clapper, or a slightly deformed trumpet. He said that he wanted to be "a child of his time." In the thirties he surmounted this limitation. Thus he got hold of the horn which, from the period of *Des Knaben Wunderhorn,* the famous collection of German folksongs, up to Gustav Mahler's symphonic sound, had been the leitmotiv of romantically expansive souls.

Beckmann's mind often held an idea in a state of dormancy until it germinated decades later. Thus we find the following passage in his early diary, dated January 28, 1909: "Saw Courbet's painting 'Halali' in Paul Cassirer's gallery. A hunters' party has assembled and a *piqueur* is blowing a large horn to announce the coming of the evening... A strangely quiet, collected mood emanates from the painting, and the *piqueur* is transformed in your own unconscious mind into a symbolic figure as he blows his jubilation outward from the picture. Something like self-renouncement after a beautiful, clear victory..."

It took thirty years for Beckmann's clock to take a full turn and reach romanticism again.

Perhaps there was a spark from the earlier romantic mind in German expressionism. Beckmann's symbols of the forties and fifties, at any rate, belonged to that world which had been lying submerged below a "realist" mirror surface for a hundred years. His triptychs especially abound with gleaming swords, spears, and shields, with fallen columns and torches, with trophies of knightly armor; their sounds are those of lutes and flutes and of the arch-romantic harp. It seems that Beckmann—perhaps the most masculine painter of Germany—still had a softly romantic streak in his character.

Since 1950 when Beckmann died in New York, that haunting horn melody has been muted. Yet its echo across the world grows stronger every year.

Rokin 85, Amsterdam, was destined to remain the address of Mr. and Mrs. Max Beckmann from the fall of 1937 until August 29, 1947, when they finally went to America. Today there is an inscription honoring the artist hewn into the stone traverse above the entrance door. But during the ten years of his not altogether

36

voluntary stay, the house served to maintain his latter-day anonymity.

It is a narrow house, exactly three windows wide, with an ornate gable. On the first floor lived a friendly, fat Dutch couple. The third floor used to be a tobacco storage room, and this was spacious enough to accommodate Beckmann's canvases and visions. It had one window and a skylight. The finished pictures stood always stacked facing the walls, and Beckmann turned just a few of them around when someone visited him. There was one paint-splashed, velvet-covered easy chair, a table, and two easels. At the foot of the longest wall lay a huge canvas roll: this was the "Resurrection," begun in 1917 and never finished. In his earlier studios in Frankfurt and Berlin, this tremendous composition had usually formed the enigmatic backdrop for his current production. In Amsterdam he must have given up the wish to finish this painting, for he never unrolled it again.

To have a roomy studio was luxury enough. The second floor contained very restricted living quarters: a bedroom and a living room, separated by sliding doors. The living room, with potted plants, a fireplace, and a few sparkling Beckmann landscapes, was warmly comfortable; the furniture, mostly inherited from Quappi's parents, had a *grand-bourgeois* air. Some objects—a Mexican vase, for instance—appear on several very early and very late paintings, touching proof that the old wanderer still clung to a few material things. The kitchen was improvised behind a curtain on the second floor landing of the staircase. There was a fierce little Pekinese dog, not always the same one through the years, but always an integral part of the Beckmanns' household.

The paintings that I had purchased were shipped from Berlin to Paris in two transports, in October, 1937 and, rather miraculously, in March, 1938. I rented an apartment in Paris which had wall space enough to hang the most important ones. The building was situated directly beside the Musée d'Art Moderne, and it had a lovely view on the Seine River with the Eiffel Tower. But one always looked back over one's shoulder toward Germany. The political developments there caused, in turn, dismay, optimism, and despair. Nevertheless, this period was one of concentrated activity; I had a clearly recognized

adversary—National Socialism—and a clear source of elation—Max Beckmann's art. Against the former one wrote articles and books, and one tried to further the latter to the best of one's ability. Both endeavors were not immediately effective. Still, seen now from a far enough distance, it appears to have been a happy time.

On January 29, 1938, Beckmann wrote me from Rotterdam:

> .. *Genuine art just cannot be made effective through hurly-burly and propaganda in a journalistic sense. Everything essential happens apart from everyday noise, only to attain a more far-reaching effect. The weak and unoriginal try to obtain a shabby fame for one day, and should get it. But this is not for us. One has to wait patiently for things to happen.— Most important is the silent show in your own rooms. By this, as time goes by, you will obtain a central force with which to direct everything, if you submerge yourself completely and consider the game of life as a contest for spiritual power—the only game which is really amusing. But this must happen almost in secret. Everything too public diminishes your strength—at least during the birth of the will and during its youth . . . Politics is a subaltern matter whose manifestation changes continually with the whims of the masses, just as cocottes manage to react according to the needs of the male and to transform and mask themselves. Which means—nothing essential. What it's all about is: the permanent, the unique, the true existence all through the flight of illusions, the retreat from the whirl of shadows. Perhaps we will succeed in this.*
>
> <div align="right">"Herzlichst" Ihr Beckmann.</div>

Beckmann knew Paris very well. In 1903 he had come here for the first time to study the Louvre. Together with Quappi he had spent several winters in the French capital. In 1931 the Galérie de la Renaissance had given him a large exhibition. The Musée du Jeu de Paume had acquired a characteristic canvas of his, "The Catfish." It looked for a while as if Beckmann's art could be integrated with the Parisian art scene. After all, had not the

<div align="center">38</div>

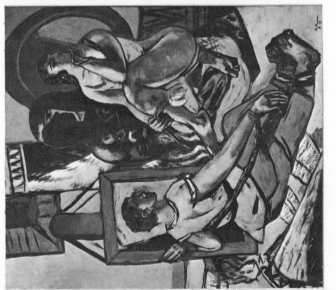

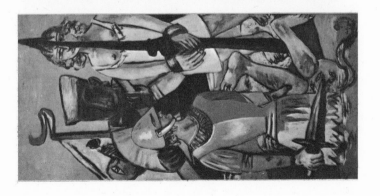

Temptation. Triptych. 1936-37

so-called School of Paris absorbed Spaniards, Italians, Roumanians, and Lithuanians? Why not a German?

Several French critics knew how important Beckmann's art really was. Waldemar George had written an appreciative introduction to the 1931 catalogue. Now, in 1938, Edmond Jaloux wrote a beautiful essay for a little Beckmann exhibition which Kati von Porada arranged in her Paris apartment. Here are some of his observations: "Beckmann's world remains a world of danger. You can see here lovely landscapes, ample and serene, sometimes even dreamlike, but they have this particularity: they receive their light from another planet. They form an immense country which belongs to them alone . . . Monsieur Max Beckmann paints with sober, frank, hard colors which hurt each other and make fascinating contrasts . . . He will remain one of the greatest figures of a movement to which the future will render justice."

Old Wilhelm Uhde, the pioneer critic who had furthered the douanier Rousseau and who had bought his first Picasso painting in 1905, came to examine the Beckmanns in my apartment. The five flights of stairs made him puff and groan, but he thought the visit well worthwhile. It was a quaint experience to see him totally absorbed before one small corner of the giant triptych "Temptation," stroking the paint with tender fingers: "Yes, this is indeed *peinture*—yes, this is correct, the vermilion spot here battling with the purple . . . " And Madame Pomaret, wife of the Minister of Public Works and very influential in artistic circles, had her portrait painted by Beckmann.

The art dealers Curt Valentin and Karl Buchholz developed a lively interest for Beckmann's art. In 1937 they founded an art gallery in New York, and they were now assembling a "stable" of modern artists. From Paris I traveled with them to Amsterdam, and we had several business talks with the master. Afterwards we undertook a stimulating trip through the Dutch countryside, visiting exquisite museums in Delft, Haarlem, and other little towns, eating cheese and drinking local beer. Valentin's grandiose plans sounded most encouraging, and over the following decades many of them did indeed materialize.

In March of 1938 the Kunsthalle in Berne, Switzerland,

showed a retrospective of Beckmann's work, followed by the Kunsthaus in Winterthur. I arranged exhibitions at art dealers' galleries in Zurich and Basel. Beckmann attended the Zurich opening. As an agreeable surprise, one of his former collectors, Baron Simolin, came straight from Germany, bought the "Self-portrait with Crystal Ball," and bravely took it back into Naziland.

Our most consequential enterprise of those years was the exhibition "Twentieth Century German Art" in the New Burlington Galleries in London in the summer of 1938. This exhibition had become necessary to counteract the nefarious influence of the big Nazi show "Entartete Kunst."

The "Degenerate Art" exhibition was being shown in Munich, Berlin, and other German cities and finally, after the *Anschluss,* in Vienna. Coincidentally, my future wife saw her first Beckmann in this deprecating frame in Vienna. Like numerous other young visitors, she conceived a lasting love for German expressionism— the exact opposite reaction of what the exhibitors wanted. Two million Germans and Austrians, according to Nazi claims, viewed these pilloried works. Many simple souls came to have fun or to find confirmation that the artistic life of the late Weimar Republic had indeed been unbearable. The press, rigidly controlled, was unanimous in its condemnation of these "—isms" on which the democratic government was said to have squandered the taxpayers' money. Raucous guides and crude inscriptions on the walls preconditioned the visitors to the Nazis' slanderous slant.

The damage done to German avant-garde artists, inside and outside the Reich, was immense. Many painters and sculptors, such as Barlach, Dix, Kollwitz, Nolde, Hofer, Purrmann, Baumeister, Schlemmer, for patriotic, sentimental, or material reasons remained in Germany. Their persecution by the Nazis was as terrible a fate as the hardships which the emigrants had to endure.

Some of the émigré artists were proud of being included in the "Entartete Kunst"; Kokoschka, in 1937, created a "Self-portrait

of a Degenerate Artist." Beckmann's first oil painting in his Amsterdam studio was titled *"Der Befreite"* ("The Liberated One") and showed him with handcuffs connected by a broken chain, the blue light of freedom playing on his bold face. But without means and relatives, without private collectors or museums to support them, many refugee artists were starving. The "Degenerate Art" show had even convinced neutral observers from other countries that the National Socialists were right and that there had been little of worth in the artistic life of the defunct Weimar Republic.

So it was high time to combat this powerfully organized slur on what we considered the genuine art of our time. But even to ferret out the appropriate works of art was a stunning task. The emigrated collectors as well as their collections were dispersed over the five continents, some of their addresses unknown. The invited artists often had no valid passports or visas, and a few of them were hesitant to be thus publicly exposed as enemies of the terrifying German colossus. The British, to tell the truth, were interested because they were outraged by Hitler's ways, not because they liked this "wild-eyed and undisciplined" kind of art whose common denominator seemed, to them, "overstatement." However, under the presidency of Augustus John many good patrons were found. Herbert Read and Kenneth Clark contributed their vast knowledge and savoir-faire. A young Swiss woman, Irmgard Burchard, traveled around, assembled, organized, and never took no for an answer.

Beckmann wrote me from Amsterdam on April 15, 1938:

> . . . I agree to the Self-portrait for London . . . Kati told me much about the efforts in Switzerland and England. I stated right away that it would be nonsense if you'd have to pay for the freight of the paintings from Switzerland. No, this the exhibitors have to do themselves. I cannot judge yet whether there is much to this London thing. But it's possible . . . I think back with pleasure to the few days we spent together in Paris. One could experience sometimes a harmony of feelings which otherwise is not frequent—that is at least something.
>
> *Always yours, Beckmann*

42

The London show opened on July 8, 1938 and lasted one month. There was an overwhelming wealth of contemporary German and Austrian art, starting with the older impressionists Liebermann and Corinth. Kandinsky, Feininger, Klee and Ernst, Marc and Macke, Rohlfs, Dix and Grosz, Pechstein, Heckel, Schmidt-Rottluff, Kirchner, Kokoschka, and Hofer and Nolde were represented by important works, and the selection was broad enough to include Schwitters, Baumeister, and Schlemmer. Sculptures by Barlach, Lehmbruck, and Marcks were also shown. Beckmann had six important oils on the walls.

The reticent Britishers, long accustomed to the assaults of the School of Paris, were disturbed by this invasion of another alien art which, to them, was quite new and perhaps too diversified. The number of paying visitors was very high, however; the press coverage, though extensive, was mixed. The *Times Weekly Edition* of July 14, 1938 brought a long review, of which the two first paragraphs are typical:

Very warm thanks are due to the promoters of the Exhibition of Twentieth-Century German Art at the New Burlington Galleries, because, except in fits and starts, the subject is practically unknown to most of us. It is easy to see why art of this kind is unpopular with the present régime in Germany, not because it is conspicuously Jewish but because it is characteristically German, if the literature of "Storm and Stress", not to speak of the romantic musical composers, can be taken as evidence. All genuine art is and must be subversive to arbitrary systems of government, but modern German art, with its emphasis upon individual expression in direct reaction from events, is peculiarly so.

The banning of such art from any country seems so ill-advised that one is reluctant to speak of its aesthetic defects, but the characteristic defect of German Expressionism would appear to be the one discussed at length by Lessing in his "Laocoön": the attempt to do in the medium of painting what is more proper to the medium of poetry—and, we might add, of music. The result is to "dump" the substance of pigment on canvas so that it calls

43

too much attention to itself at the expense of unity in the work ...

The *Times Literary Supplement* of July 23 reproduced Beckmann's "Temptation" on the front page. Naturally I bought about twenty copies.

A Pelican paperback, *Modern German Art,* was sold in one folder together with the catalogue. It contained thirty-two reproductions, an introduction by Herbert Read, and an excellent text by Peter Thoene—the latter name being a pseudonym for Oto Bihalij-Merin, a well-known Yugoslav writer on art. Thoene called Beckmann "the most vital of living German painters" and continued: "The world which Beckmann has built up of colour and form is ghostly and unreal. In this world life does not proceed in three-dimensional, Euclidian space. The allegories which have come from his brush depict a disguised, acrobatic, somnambulistic crew crowding steeply upwards, Gothic fashion." He defined Beckmann as "the hyper-individualist."

Beckmann and I crossed the English Channel in a gay, free, enterprising mood. We stayed in London from July 20 to August 2. There were numerous receptions, literary teas, and interviews. Beckmann was kept very busy. Sometimes I served as his interpreter and guide; it was his first visit, and I had been in London twice before. I remember well his delighted surprise when he discovered the rainbow-hued cosmic fantasies of William Blake in the Tate Gallery—a distinct enrichment of his painterly world.

The exhibition program also included the banned German music. On July 28 the *Three-Penny Opera* sounded for the first time in English, ragged and depressing. There was chamber music by Schoenberg, Webern, Eisler, Hindemith, Krenek, and Berg, falling on completely unprepared ears, yet spreading puzzled excitement.

Altogether a "fighting" show! Its importance may be compared to the impact of the New York Armory Show of 1913—which, by the way, already had contained works of Lehmbruck and Kandinsky. These, exactly a quarter-century

later, still had not lost their shock value. Some elements of modern British art can, I'm sure, be traced back to that artistic "invasion" of 1938.

On July 21, Beckmann gave the first lecture of his life. A confusing and imposing crowd assembled for the occasion: earls, anti-Fascists in proletarian garb, dignitaries, elegant, slender young writers, and dowagers. When Beckmann tramped up to the dais, he looked like one of those legendary "giants walking on the earth." He spoke with conviction and a deep earnestness that captured the audience. An English translation was read immediately afterwards.

Here is the text of that programmatic lecture.

ON MY PAINTING
By Max Beckmann*

Before I begin to give you an explanation, an explanation which it is nearly impossible to give, I would like to emphasize that I have never been politically active in any way. I have only tried to realize my conception of the world as intensely as possible.

Painting is a very difficult thing. It absorbs the whole man, body and soul—thus I have passed blindly many things which belong to real and political life.

I assume, though, that there are two worlds: the world of spiritual life and the world of political reality. Both are manifestations of life which may sometimes coincide but are very different in principle. I must leave it to you to decide which is the more important.

What I want to show in my work is the idea which hides itself behind so-called reality. I am seeking for the bridge which leads

*Max Beckmann, "On My Painting" from Robert L. Herbert, Editor, MODERN ARTISTS ON ART: Ten Unabridged Essays © 1964. Reprinted by permission of Prentice-Hall, Inc., Englewood Cliffs, New Jersey.

from the visible to the invisible, like the famous cabalist who once said: "If you wish to get hold of the invisible you must penetrate as deeply as possible into the visible."

My aim is always to get hold of the magic of reality and to transfer this reality into painting—to make the invisible visible through reality. It may sound paradoxical, but it is, in fact, reality which forms the mystery of our existence.

What helps me most in this task is the penetration of space. Height, width, and depth are the three phenomena which I must transfer into one plane to form the abstract surface of the picture, and thus to protect myself from the infinity of space. My figures come and go, suggested by fortune or misfortune. I try to fix them divested of their apparent accidental quality.

One of my problems is to find the Self, which has only one form and is immortal—to find it in animals and men, in the heaven and in the hell which together form the world in which we live.

Space, and space again, is the infinite deity which surrounds us and in which we are ourselves contained.

That is what I try to express through painting, a function different from poetry and music but, for me, predestined necessity.

When spiritual, metaphysical, material, or immaterial events come into my life, I can only fix them by way of painting. It is not the subject which matters but the translation of the subject into the abstraction of the surface by means of painting. Therefore I hardly need to abstract things, for each object is unreal enough already, so unreal that I can only make it real by means of painting.

Often, very often, I am alone. My studio in Amsterdam, an enormous old tobacco storeroom, is again filled in my imagination with figures from the old days and from the new, like an ocean moved by storm and sun and always present in my thoughts.

Then shapes become beings and seem comprehensible to me in the great void and uncertainty of the space which I call God.

Sometimes I am helped by the constructive rhythm of the Cabala, when my thoughts wander over Oannes Dagon to the last

days of drowned continents. Of the same substance are the streets with their men, women, and children; great ladies and whores; servant girls and duchesses. I seem to meet them, like doubly significant dreams, in Samothrace and Piccadilly and Wall Street. They are Eros and the longing for oblivion.

All these things come to me in black and white like virtue and crime. Yes, black and white are the two elements which concern me. It is my fortune, or misfortune, that I can see neither all in black nor all in white. One vision alone would be much simpler and clearer, but then it would not exist. It is the dream of many to see only the white and truly beautiful, or the black, ugly and destructive. But I cannot help realizing both, for only in the two, only in black and in white, can I see God as a unity creating again and again a great and eternally changing terrestrial drama.

Thus without wanting it, I have advanced from principle to form, to transcendental ideas, a field which is not at all mine, but in spite of this I am not ashamed.

In my opinion all important things in art since Ur of the Chaldees, since Tel Halaf and Crete, have always originated from the deepest feeling about the mystery of Being. Self-realization is the urge of all objective spirits. It is this Self for which I am searching in my life and in my art.

Art is creative for the sake of realization, not for amusement; for transfiguration, not for the sake of play. It is the quest of our Self that drives us along the eternal and never-ending journey we must all make.

My form of expression is painting; there are, of course, other means to this end such as literature, philosophy, or music; but as a painter, cursed or blessed with a terrible and vital sensuousness, I must look for wisdom with my eyes. I repeat, with my eyes, for nothing could be more ridiculous or irrelevant than a "philosophical conception" painted purely intellectually without the terrible fury of the senses grasping each visible form of beauty and ugliness. If from those forms which I have found in the visible, literary subjects result—such as portraits, landscapes, or recognizable compositions—they have all originated from the senses, in this case from the eyes, and each intellectual subject has been transformed again into form, color, and space.

47

Everything intellectual and transcendent is joined together in painting by the uninterrupted labor of the eyes. Each shade of a flower, a face, a tree, a fruit, a sea, a mountain, is noted eagerly by the intensity of the senses to which is added, in a way of which I am not conscious, the work of my mind, and in the end the strength or weakness of *my soul*. It is this genuine, eternally unchanging center of strength which makes mind and sense capable of expressing personal things. It is the strength of the soul which forces the mind to constant exercise to widen its conception of space.

Something of this is perhaps contained in my pictures.

Life is difficult, as perhaps everyone knows by now. It is to escape from these difficulties that I practice the pleasant profession of a painter. I admit that there are more lucrative ways of escaping the so-called difficulties of life, but I allow myself my own particular luxury, painting.

It is, of course, a luxury to create art and, on top of this, to insist on expressing one's own artistic opinion. Nothing is more luxurious than this. It is a game and a good game, at least for me; one of the few games which make life, difficult and depressing as it is sometimes, a little more interesting.

Love in an animal sense is an illness, but a necessity which one has to overcome. Politics is an odd game, not without danger I have been told, but certainly sometimes amusing. To eat and to drink are habits not to be despised but often connected with unfortunate consequences. To sail around the earth in 91 hours must be very strenuous, like racing in cars or splitting the atoms. But the most exhausting thing of all—is boredom.

So let me take part in your boredom and in your dreams while you take part in mine which may be yours as well.

To begin with, there has been enough talk about art. After all, it must always be unsatisfactory to try to express one's deeds in words. Still we shall go on and on, talking and painting and making music, boring ourselves, exciting ourselves, making war and peace as long as our strength of imagination lasts. Imagination is perhaps the most decisive characteristic of mankind. My dream is the imagination of space—to change the optical impression of the world of objects by a transcendental arithmetic progression of the inner being. That is the precept. In

48

principle any alteration of the object is allowed which has a sufficiently strong creative power behind it. Whether such alteration causes excitement or boredom in the spectator is for you to decide.

The uniform application of a principle of form is what rules me in the imaginative alteration of an object. One thing is sure—we have to transform the three-dimensional world of objects into the two-dimensional world of the canvas.

If the canvas is only filled with a two-dimensional conception of space, we shall have applied art, or ornament. Certainly this may give us pleasure, though I myself find it boring as it does not give me enough visual sensation. To transform height, width, and depth into two dimensions is for me an experience full of magic in which I glimpse for a moment that fourth dimension which my whole being is seeking.

I have always on principle been against the artist speaking about himself or his work. Today neither vanity nor ambition causes me to talk about matters which generally are not to be expressed even to oneself. But the world is in such a catastrophic state, and art is so bewildered, that I, who have lived the last thirty years almost as a hermit, am forced to leave my snail's shell to express these few ideas which, with much labor, I have come to understand in the course of the years.

The greatest danger which threatens mankind is collectivism. Everywhere attempts are being made to lower the happiness and the way of living of mankind to the level of termites. I am against these attempts with all the strength of my being.

The individual representation of the object, treated sympathetically or antipathetically, is highly necessary and is an enrichment to the world of form. The elimination of the human relationship in artistic representation causes the vacuum which makes all of us suffer in various degrees—an individual alteration of the details of the object represented is necessary in order to display on the canvas the whole physical reality.

Human sympathy and understanding must be reinstated. There are many ways and means to achieve this. Light serves me to a considerable extent on the one hand to divide the surface of the canvas, on the other to penetrate the object deeply.

As we still do not know what this Self really is, this Self in

49

which you and I in our various ways are expressed, we must peer deeper and deeper into its discovery. For the Self is the great veiled mystery of the world. Hume and Herbert Spencer studied its various conceptions but were not able in the end to discover the truth. I believe in it and in its eternal, immutable form. Its path is, in some strange and peculiar manner, our path. And for this reason I am immersed in the phenomenon of the Individual, the so-called whole Individual, and I try in every way to explain and present it. What are you? What am I? Those are the questions that constantly persecute and torment me and perhaps also play some part in my art.

Color, as the strange and magnificent expression of the inscrutable spectrum of Eternity, is beautiful and important to me as a painter; I use it to enrich the canvas and to probe more deeply into the object. Color also decided, to a certain extent, my spiritual outlook, but it is subordinated to light and, above all, to the treatment of form. Too much emphasis on color at the expense of form and space would make a double manifestation of itself on the canvas, and this would verge on craft work. Pure colors and broken tones must be used together, because they are the complements of each other.

These, however, are all theories, and words are too insignificant to define the problems of art. My first unformed impression, and what I would like to achieve, I can perhaps only realize when I am impelled as in a vision.

One of my figures, perhaps one from the "Temptation," sang this strange song to me one night—

Fill up again your pumpkins with alcohol, and hand up the largest of them to me. . . . Solemn, I will light the giant candles for you. Now in the night. In the deep black night.

We are playing hide-and-seek, we are playing hide-and-seek across a thousand seas. We gods, we gods when the skies are red at dawn, at midday, and in the blackest night.

You cannot see us, no you cannot see us but you are

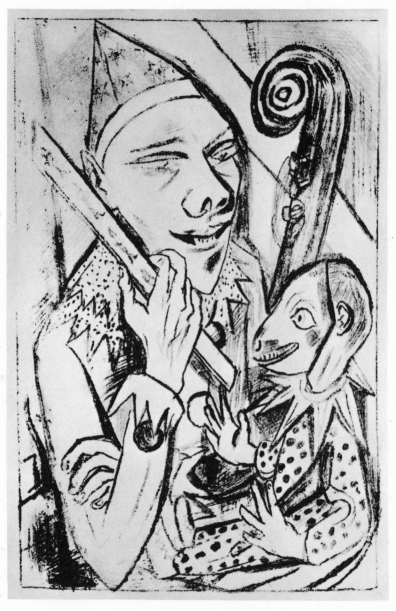

Pierrot and Mask (Self-portrait). Lithograph. 1920

ourselves. . . . Therefore we laugh so gaily when the skies are red at dawn, at midday, and in the blackest night.

Stars are our eyes and the nebulae our beards. . . . We have people's souls for our hearts. We hide ourselves and you cannot see us, which is just what we want when the skies are red at dawn, at midday, and in the blackest night.

Our torches stretch away without end . . . silver, glowing red, purple, violet, green-blue, and black. We bear them in our dance over the seas and the mountains, across the boredom of life.

We sleep and stars circle in the gloomy dream. We wake and the suns assemble for the dance across bankers and fools, whores and duchesses.

Thus the figure from my "Temptation" sang to me for a long time, trying to escape from the square on the hypotenuse in order to achieve a particular constellation of the Hebrides, to the Red Giants and the Central Sun.

And then I awoke and yet continued to dream . . . Painting constantly appeared to me as the one and only possible achievement. I thought of my grand old friend Henri Rousseau, that Homer in the porter's lodge whose prehistoric dreams have sometimes brought me near the gods. I saluted him in my dream. Near him I saw William Blake, noble emanation of English genius. He waved friendly greetings to me like a super-terrestrial patriarch. "Have confidence in objects," he said, "do not let yourself be intimidated by the horror of the world. Everything is ordered and correct and must fulfil its destiny in order to attain perfection. Seek this path and you will attain from your own Self ever deeper perception of the eternal beauty of creation; you will attain increasing release from all that which now seems to you sad or terrible."

I awoke and found myself in Holland in the midst of a boundless world turmoil. But my belief in the final release and

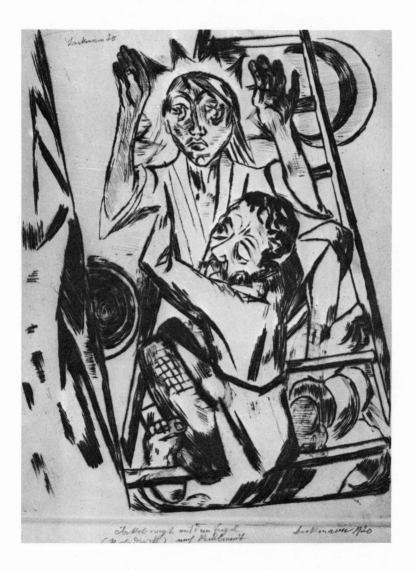

Jacob Wrestling with the Angel. Etching. 1920

absolution af all things, whether they please or torment, was newly strengthened. Peacefully I laid my head among the pillows . . . to sleep, and dream, again.

The paintings which represented Beckmann's art in the New Burlington Galleries were selected to show the recent development of his style. They were the following: Genoa (1927), Skaters (1932), Woodcutters (1932), The King (1937), Temptation (1936-1937), and Quappi with Fur (1937), as well as some of his graphics. Since Beckmann had never been shown in England before, the exhibitors thought that a little explanatory brochure might be helpful. Beckmann recommended an essay of mine, and a condensed translation of this was mimeographed and laid out for distribution on a table beside the triptych "Temptation." Its title: "Max Beckmann's Mystical Pageant of the World."

The German title was "Das Welttheater des Malers Max Beckmann," which was meant to have connotations of Calderon's World Theater and of the Salzburg Everyman. When I first had sent this essay from Paris to Amsterdam, Beckmann had telegraphed back: "Agree with every word." The little study had a persistent, quasi-subterranean influence; some of its formulations have crept up again and again in writings about German expressionism. The word "post-Christian," for instance, which I coined for the comparison of Beckmann's triptychs with Gothic altar-pieces, has become a common term in cultural criticism.

Beckmann himself was very reticent in interpreting the enigmas of his own art. His unconditional acceptance of my essay justifies its exhumation (slightly condensed) thirty years after its first appearance.

54

MAX BECKMANN'S MYSTICAL PAGEANT
OF THE WORLD (1938)

Master of Ceremonies

Sometimes, when I daydream among his paintings, Max Beck-
mann suddenly appears before me as the Master of Ceremonies of
his own show, inviting the public with a grandiose gesture to
enter his theater: "Come one, come all, ladies and gentlemen,
take your seats in front of the narrow frame which shall soon
contain the motley reflections of life." There he stands in front
of his stage: a giant with the figure of a wrestler and the head of a
philosopher. A trace of tired sarcasm is visible around his wide
mouth, intense knowledge of the world in his deep-sunken eyes,
all the great ideas from the Rig-Vedas to the most modern anthro-
pology behind the vast dome of his forehead: an interesting host
who asks nothing from us except that we trust ourselves to his
guidance.

"Ladies and gents, walk right in, you won't regret it!" I hear
him shout through my waking dream. "Something is offered for
everyone. We'll pull aside the dusty curtain of everyday. Pay
attention well, because what you will witness here is a new world.
Variety show? Tragedy? Circus? Play or reality? An extract of
each of these. I'll change the sets within my golden frame, and
perhaps you'll see the basic drama of Adam and Eve, or the
incestuous tragedy of the siblings Siegmund and Sieglinde, or the
decadent twilight of our immediate past, or the holy figures of a
mythical future—irony and deeper meaning, yes indeed! Sit
down, honored public. Not a chance that you'll be bored. My
theater brings you all the epochs of world history, innumerable
characters, pain and pleasure in concentrated doses. The show is
about to start!"

Program
Entering Beckmann's imaginary theater, we'd like to receive

some program notes concerning time and place of the action. Well, there's a paper slip whirling down toward us. It informs us that the play's originator was born in 1884 in Leipzig. A large cast is listed. Won't we be confused by the scenes with goddesses and gangsters, profiteers, cripples, sadists and saints, naked heroes, whores and society ladies, businessmen and acrobats and fabled animals? We shall see, when the curtain rises, what actions and motivations these characters will show. They might even have a message for us.

A synopsis gives the bare outline of the action: it is the emergence of humanity's myths behind the glaringly overpainted flats and props of present-day actuality.

The drama's author is his own director, manager, and stagehand; he even mingles with the cast in varied costumes.

Place: Germany, France, Holland.

Time: During the Great War, as a medical corpsman, the thirty-year old artist absorbs all the horrors of his times. He acquires a tough skin. Vehemently he participates in amusements and revolts of inflation-racked Berlin. Bourgeois security appears as a *fata morgana*. And then the timely piece expands to embrace timelessness.

Curtain

The Great War was the iron curtain which cut off the earlier drama, "International Humanism." That play had ended as a tragedy. There was no view, no perspective any more, only this curtain of blue steel and red blood. Behind it, with hollow rumblings, the darkened European scenery was struck.

First Act: The Wooden Shack

Max Beckmann, the artist, reequipped his little private theater. Before the war its scenery had been naturalistic and appointed with a certain old-fashioned luxury. When the curtain rose again in 1917, Beckmann's stage looked thoroughly modern—which meant shabby and decimated. The pale statues of idealism had been shattered, the wings and flies of the old German *Kultur* had been torn to shreds and discarded. What remained was a small, bare, wooden shanty.

56

The first act which Beckmann now puts on stage is a notturno, subdivided into scenes such as "The Night" and "The Dream."* The lack of space is apt to produce claustrophobia, and no exit is visible. No horizon: the background is boarded up. The surrounding wooden boards seem to infect the actors, limbs become wooden, faces become insensitive masks. Legs and arms are twisted into exact parallels and splintery angles, and the regular pattern seems to indicate that everything is in order: torturers and victims agree to the cruel shape of things.

There is no glimmer of dawn, the light comes from candles and petrol lamps, the stage rectangle is hermetically sealed off against help or pity. Gangsters rule the night. Strangely enough, the colors have an eery, otherworldly beauty. They can be compared to multicolored glass windows of medieval cathedrals: the suffering martyrs don't know that their blood has turned into precious ruby-glass; the transfiguration is no consolation in the middle of torture, but the beholder at least receives a perverse enjoyment from the peacock-hued visual glorification. No wonder that many of Beckmann's figures, up to 1921, keep their eyes tightly closed to make the surrounding night still more opaque.

Even in open-air scenes like "Christ and the Adulteress," † the horizon is shut out, eliminated by a prosaic wooden fence.

This restrictive tendency was common to many productions of the period. Cubists and Dadaists had already taken refuge in a new puritanism. Beckmann chose to concentrate his stories by keeping his characters fenced in.

Why did the artists of the time aspire to a narrow point of view? They had seen all too distinctly what megalomania could lead to, they had witnessed the fact that one shot in the Balkans could cause millions of deaths. They saw how the central European currencies became devaluated day in, day out, and they experienced painfully how those paper millions did not correspond to any real values. Concentration, crystallization, yes

*"The Night," 1918-1919, is now in the Kunstsammlung Nordrhein-Westfalen, Düsseldorf; "The Dream," 1920, in the collection of Morton D. May, St. Louis.

†Now in the City Art Museum of St. Louis.

even mechanization appeared as the saving trend in painting, sculpture, architecture, and the theater arts. And Beckmann proclaimed himself to be "a child of his time." So he put the typical evils and weaknesses of the twenties into his show-box; exact visibility would eliminate unforseeable effects, and the uttermost compression would force a catharsis.

Dramatis personae

There is one central character who reappears all through the play, advancing the action, commenting, warning, enjoying himself, mingling with his fellow-actors or spinning out monologues: this character is the ego, the self-portrait of the artist. His attributes, like those of medieval saints, show what he stands for, and they change according to the progress of the fable: mask or slapstick in the early grotesque carnivals and torture chambers; black derby hat and cigarette or white beach cap in the period of bourgeois contentment; a crystal ball or the brass horn of fairy tales when he finally advances to the aboriginal concerns of humanity.

In 1927 it looked as if the outward bourgeois regularity was congruent with the inner character, in the "Self-portrait in Dinner-jacket."* This man steps before his public en face, exactly symmetrical, self-reliant, in black-and-white stylized elegance: this is the successful master at the height of his career, in agreement with the status quo, the stationary axis of his world. Even the curtain folds behind him are hanging vertically, there exists no disturbance, no turbulence. One is reminded of Durer's self-portrait of 1500 with his long, symmetrical locks which also showed a bourgeois master at the pinnacle of acceptance; forgotten was the disquieted, inquisitive glance which the apprentice Durer had once directed at us. The formula of the mature individual has conquered all doubts.

But the play goes on, as it must. Reality remains unreliable. There will be upheavals, all the stage decorations are thrown topsy-turvy by elemental events. The bourgeois republic, symmet-

*At the time of the writing, this picture was in the "Degenerate Art" exhibition in Germany; it was soon thereafter acquired by the Germanic Museum of Harvard University.

rically balanced between political extremes, is overthrown. Ten years after that scene of regularity we meet Beckmann again. In 1937 the well-defined, sharply contoured contentment has evaporated. A magician in timeless garb stands before us, holding a large, shimmering crystal ball. From deeper sockets the glance does not challenge the viewer any more, the shadowy eyes look beyond actuality into more distant worlds. They now see oceans welling up with curved horizons, sunken islands, half-human and superhuman creatures from forgotten fables, titans in forbidden incest, kingly demigods looming in the dusk of prehistory: the basic symbols of life.

Beckmann keeps faith with his characters and this makes him the dramatist among painters. In the "passing show" of his fleeting female shapes we recognize two or three recurrent types, individual women who have to act out their parts to the bitter or happy end. And even his inanimate objects seem to experience tragedies and comedies.

Very conspicuous is the fish which keeps popping up in his compositions as a comical, tragic, or mysterious leitmotiv. Beckmann's fish has a strange biography. In the "Dream" of 1921 his role is already quite abstruse: a cripple carries the slippery creature under his arm stump, and while the human carrier is hemmed in by all sorts of calamities, the fish is gayly heaven-bound. During that nocturnal, catacomb period of Beckmann's art the fish has a mystical significance, akin to the *ichthyos* of early Christianity. But soon he reverts to sober reality. On a beach he is held up by an elegant young man to frighten giggling ladies. Or he lies dead and stupid on a kitchen table. Suddenly, in 1934, he recollects his mystical faculties: he flies like a gigantic kite through space, and humans travel on his back.

Every single one of Beckmann's objects has at some time its moment of animation and resurrection. The trite mask from a civilized ball is changed into the silvery visor of an amazon. The handcuffs of the old chamber of horrors become golden, princely bracelets—yet without quite abandoning their original function. To follow these secret puzzles through their ramifications is a fascinating pastime.

There are, for instance, the candles: the wretched lighting

59

devices of the early, squalid, overcrowded scenes suddenly become main characters. Abandoned by their human masters, they look at themselves in a mirror. One of them has given up the combat against darkness, it has fallen over, sending up a tired whiff like a departing soul.

There is a tricky resemblance to the Mickey Mouse films in which a chair starts dancing or a house is allowed to swallow and spew forth its inhabitants. Indeed, Beckmann's objects have some toy-like traits: the child, like the primitive, is surrounded by magically animated things. Each object can turn into a subject having its own well-defined character and action radius. Yet this childishness has a deeper significance: it brings back the lost naiveté with all its nostalgic charm.

This second naiveté on a higher level characterizes the second act of Beckmann's theatrical production.

Second Act: A Child of the World

Beckmann's middle period, up to around 1930, is characterized by a new, sophisticated childlikeness, formally defined by geometrically simplified contours, lack of any pattern or design within these contours, and planes of clear local colors.

This began with an almost simplistic trend, with blue-eyed, blond-haired infantilism: a few country bumpkins had lost their way and then found themselves in the middle of the big city, helpless among its vices and brutality. At first this style made fun of the unspoiled childish heart, it started out as irony. But soon it lost its smart-alecky aggressiveness and became a renewed faith in simple, tactile values: a faith that the things of this world could be grasped and understood.

Beckmann's figures have now left the nocturnal cellars and slanting attics; they have acquired more elbow room, and they can be viewed more leisurely, more distinctly. Treetops are stylized into globes and cones, streets seem to be put together with a child's building blocks, humans are sometimes robot-shaped, airplanes hang in the sky like toys: everything can be formulated mathematically. Technology appears as a child's game. At first the natural object is violated by geometry, but soon it is reduced quietly to its formulae according to the laws of nature, each thing

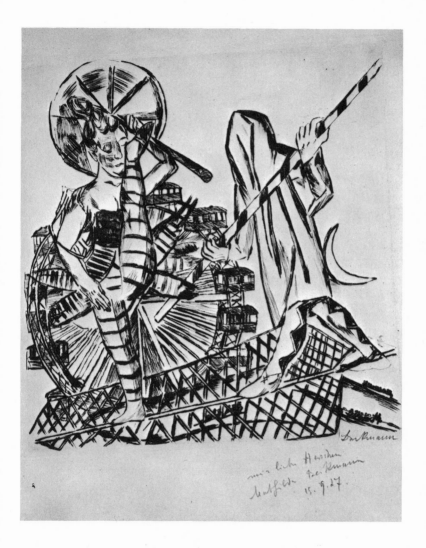

Tightrope Dancers. Etching. 1921

becomes its platonic idea. Every body is allowed to adopt the most consistent, crystalline, ideal shape; a friendly regularity takes possession of the earth's surface.

Yet the viewer is not quite at ease with this radiantly clean, Sunday orderliness. Can we trust the childlikeness of the erstwhile satirist? Is it really Beckmann's opinion that one can go around objects without wariness, that there are exits out of every impasse, that the domination of the world has become a child's play?

Not really. Beckmann has only made up his mind to be and let be, to distrust abstractions and the "truth" of various prophets; he wants to enjoy the lustrous, beautiful surface of real things. With an indomitable hunger for light, color, and matter he devours, so to say, the phenomena at hand. The unrelenting drive to shape objects into simplified forms serves only to make his world more concrete.

The douanier Rousseau, that St. Francis among painters, taught Beckmann the happiness which can be expressed by outwardly childish means. He is not a true primitive, though, not a *peintre du Sacré-Coeur,* as Wilhelm Uhde used to call his beloved Sunday painters. Beckmann remains a nervous, complicated man who has gone through refined tortures and strange lusts. His temporary primitivity is only a try at salvaging some loveliness from the actual world.

This endeavor cannot succeed for long. The protective armor of a simplified form will not suffice. The solution has to be found: saying yes to the immensity of events, surrendering to the limitless stream.

Third Act: Departure

A technical novelty initiates the third act: the airplane perspective. This viewpoint expands the horizon, the aeronaut has a wider comprehension of the objects in the plain, but his dignity is menaced by vertigo and unsteadiness.

The horizon becomes an upward curve. The sea swells up from afar. The new depth—of space and of soul—does not take on bombastic character. The problem is simply that the wooden box does not suffice any more; the stage sets are pushed aside, from

behind the board fence cosmic light and nostalgia flood the picture.

Around 1932 Beckmann can even discard his confinement in time, he can do without the present. He gets off the tightrope which connects past and future, and he moves freely across the oceans of time on both sides. The postwar types—the profiteers, amputees, discharged officers, and costumed heroes—disappear. Nudity takes anew its age-old place integral to art.

"Man and Woman": that's how simple the scene of Beckmann's drama has now become.* Two nudes, large as life, desert-yellow earth, a few gigantic plants: that is all. Rosy and sky-blue hues: the scenery glows in the first rays of beginning world-history. The plants are thick, seemingly made of flesh, as if the process of creation had not yet been diversified. The young woman is resting self-contentedly like a lovely cat. She holds and contemplates a blossom. The man has turned away and stepped beyond the horizon, the curvature of the earth hiding his lower legs. His giant shoulders and small head are awash with blue infinity. He is surfeited with paradise and with his female companion, he thirsts for distances, he gazes out into freedom.

Consequently, in the last years, the outer frame of the picture does not suffice any longer: Beckmann adopts the form of the triptych. The first triptych is called "Departure." † Three very large panels form a kind of altar: a heathen, or more correctly expressed, a post-Christian altar. The three parts can also be understood as a three-act drama set within the dramatic development of Beckmann's art, like the play within the tragedy of *Hamlet* or the Helena-pantomime in *Faust:* as the summing-up of the most important ideas and at the same time as an element of propulsion within the principal action.

The two side panels show again the torture chamber, just as in the early scenes: in the dusk men and women are tied to columns and to each other, bloody arm stumps are raised upward, mouths and eyes are bound up with scarves. A nocturnal staircase forms the background, enigmatic faces spy over the banister, the hollow

*This picture was painted in 1932 and acquired by me in 1933.

† 1932-1935; now in the Museum of Modern Art, New York.

sound of a big drum echoes frighteningly through the house. The shabby petrol lamps are here again, the steel handcuffs, the fish banished on dry land. It is a nightmare, presenting not the concrete deprivation of the postwar period, but the helplessness of life which has lost its way in darkling, confusing space.

However, the middle scene takes place on the high sea. A fishing boat carries titanic figures, masked, veiled, or crowned, half clothed in regal purple. A king with an Assyrian beard gestures toward the infinite distance. A woman is holding a tender, golden-haired boy exactly in the center of the picture.

The two wings together form the foreground: the old wooden shack is finally revealed as a mere surface phenomenon. In the center, where there had been no exit, the wall is cleft asunder as by a magic signal, and belatedly we become aware that the limitless depth was always waiting out there. It was the unconscious essence behind the theatrical decorations, but the hurly-burly in the foreground was too loud, too busy to let the silent dimension of depth be noticed. Now the oceanic azure light emerges.

Beckmann's economy of art has here produced a new balance. The night people with broken and junky attributes: are they the victims which fate demands so that the purple-garbed titans can set sail, and so that the white-golden baby boy may come forth? Or are people tortured for the express purpose of producing, by contrast, the sublime ideals? It's a moot question. No concrete history is presented here. This is not painted literature. Several meanings cross each other, aboriginal heathen drives and Christian salvation wishes, preconscious memories, subliminal anxieties, and aimless bliss.

The latest stage reached by the progressing play-action is the second triptych: the "Temptation" of 1937. The process of widening, of opening up, has gone further, compared to the "Departure": only the center panel presents a narrow interior, both wings show the open sea.

In the dark background of the center room stands a bisexual idol of bluish metal with two faces and many breasts. Like two split emanations from this original unity of form, a youth and a young woman are sitting in the foreground, among fallen columns

64

and sacrificial flames. The boy, simply clad like a shepherd, has his handsome, pure Greek profile turned toward the half-naked, alluring woman. His arms and legs are bound by chains, so he cannot reach her. She is resting her chin on her hand as though listening to far-off memories. Floating between them passes the silent tragedy of their lives.

On the side wings the riches of the world expand in iridescent colors, ignored by the bewitched shepherd boy. A liveried bellhop scurries along, presenting a crown on a salver. Half submerged by the sea stands a woman warrior in silver armor—perhaps a symbol of fame. Several other women await their savior. The whole, rich, oceanic universe is at the disposal of the youth, but he is magically encircled, bound to his narrow abode.

This abode, surrounded on both sides by water, seems like Noah's ark. And suddenly we understand why the early, tight wooden shack gave us a feeling of seasickness, with its noisy mingling of incongruous objects: the dim everyday building of life was floating all along on heaving endlessness. Insipid actuality is but a drifting island amidst everlasting space and time.

Critique

When the drama is ended, the critics perform their satyr play. Beckmann has received esteem, analysis, and enthusiasm as well as shrill abuse. Even well-meaning reviewers, acknowledging the painterly qualities, opined that the cabinet of horrors was badly invented and exaggerated. Yes, Beckmann had a deep-seated distrust of his fellow men—and was this not justified? Did the torture chambers not become ugly reality? However, when the sadistic underworld, visible to all, gained the upper hand, Beckmann had already progressed to wider vistas. May we perhaps hope, in spite of our grim skepticism, that those deeper possibilities of the occidental psyche will realize themselves?

One thing can be deduced clearly from Beckmann's development: Germany did not need the "therapy" of the Nazi revolution to get rid of the toxins of the postwar and inflation period. The national organism had absorbed the toxoids by its own force, the "degenerate" symptoms of profiteering and civil-war mentality were not on the national agenda any longer when Hitler's

storm troopers were called upon to put things to order.

Beckmann surely was not "degenerate." He was the barometer registering the frightening compression of the postwar atmosphere. Through sobriety, precision, and creativity he tried to conquer dread and disaster. He had a strong stomach and could digest and formulate even filth and decay. Thus arose in him an untamable hunger for life. The pageant of his art comprised urbane elegance, magic contemplation, erotic-psychoanalytical conflicts, archaic and heathen motives: the whole drama of our time and its most distant backgrounds melting away in blue distances.

On this hopeful note ended my essay of 1938.

The exhibition in the New Burlington Galleries in London stirred up quite a controversy. The Führer himself took note of it, as the *London Times* reported on July 14: "In opening a national exhibition of German art in Munich, Herr Hitler on Sunday referred to the London exhibition, which, he said ironically, was designed to expose the contrast between the cultural greatness of an earlier period and the poverty of the German art of to-day. He suspected that business interests were at work. But in any case he supposed somebody had to beat the drum on behalf of the Bolshevist Government."

The "business interests" did not do so well. Beckmann did not sell a single picture in England. We planned to have the "Modern German Art" show travel to Paris and to New York in time for the World's Fair; both projects could not be realized. So in the end many artists and their enthusiastic supporters had a rather hopeless feeling.

On September 3, 1938, Beckmann and I signed a contract: I was going to pay him a fixed monthly sum, and in return I was to receive two pictures a month. One out of every five paintings was to be of greater importance or size.

The monthly payments were designed to alleviate the insecurity of his situation which, at that very moment, was truly overwhelming. I hoped to make it easier for him to concentrate on his creation. Up to then I had spontaneously bought paintings

in his studio or in his exhibitions, but Beckmann wished for a little more solidity in business matters. In the twenties he had been under contract to the Berlin art dealer Alfred Flechtheim, and from summer 1930 on for several years to J. B. Neumann, who ran galleries in Munich and New York. To Beckmann, the world seemed one big adventure anyway, a floating phantasmagoria of phenomena, and he did not need additional uncertainties for his inspiration!

It was not always easy for me to fulfill our contract. But I found out that I could do without certain luxuries, and toward the end of the month I sometimes skipped lunch. I managed to keep up the monthly payments until May, 1940, when military events forced a termination.

Max and Quappi Beckmann spent the winter of 1938-1939 in Paris without giving up their Amsterdam domicile. They rented a small, funnily elegant flat, 17 rue Massenet, with thin-legged gilt furniture and faded silk curtains. Paris was, of course, the patented art capital of the world, and even though Curt Valentin began showing Beckmann in New York, we thought it important that Beckmann should "make the scene" here. Max and Quappi had stayed in Paris many times before and loved the city.

But 1938 was not an auspicious year for German art and artists anywhere, especially not in Paris. Hitler's emissaries, cultured, well-mannered gentlemen to be sure, could only parrot what the propaganda ministry instructed them to say; and the defamation of émigrés in all the capitals was part of their "diplomatic" tasks. Distrust of anti-Hitler refugees was spreading, spy-scares were skilfully instigated by the Nazi Fifth Column. As a result most Frenchmen had a lively aversion against anybody who had a *boche* accent. And Beckmann's artistic expression on canvas doubtless had this *boche* accent.

Naturally there were influential people in Paris artistic circles who were far above such prejudices. But the possibility for a breakthrough seemed more and more remote. After several other projects had failed, I rented the Galérie Poyet in the rue de la Boëtie to expose Beckmann's art at least to some discussion—I already had transported the paintings there—but the political developments of 1939 were to put an end to all such plans.

67

In spite of these outward failures, I was happy that Beckmann resided in my beloved Paris! These, for me, were months of tremendous stimulation. We often sat together at Fouquet's or in the lobby of the Hotel George V, or we wandered over bridges and squares. Beckmann liked to surprise me—and perhaps also himself—with enormous speculations. His word-pictures of continents floating through primeval oceans were so vivid that the listener saw land masses shifting and turning like ice floes. Or he unrolled the panorama of history by re-interpreting the name of our biblical father Abraham as A-brahma, non-brahma. The theory of relativity as well as the doctrine of reincarnation had the strangest functions in his thinking. Only those teachings which evoked pictorial fantasies induced strong currents in his brain. When I could not follow his flights of fancy, or when I contradicted him out of rationalistic reticence, he listened to my objections with not unfriendly nods and then concluded: "Well, you'll still come around to my ideas."

At the time he read many foreign books, but always in German translations. He loved Joseph Conrad, Flaubert, Goethe, and certain German romantic writers. The Bible and Indian scriptures had a marked influence on his painting. In music he liked Hindemith, Bartok, and gypsy tunes. He even wished that the genuine gypsy music should replace the common commercialized jazz. The earlier strident forms of jazz around 1920 he had admired, but those had disappeared by 1938. I remember that he was fascinated by a quadrille played and danced by a troupe from Martinique.

When we talked politics—which was inevitable—he visualized it as a play and counterplay of personalities and crowds; parties and their theoretical programs interested him but little.

He very much enjoyed being driven around in my open Renault. He himself did not drive. In Frankfurt, ten years earlier, the Beckmanns had owned a little car, and Frau Quappi had sometimes given me a ride when she saw me waiting at a streetcar stop. Now I drove them to Versailles and other beautiful places near Paris. Beckmann preferred a very slow tempo. Leaning back in a dignified pose, his new, soft, wide-brimmed hat flapping, he looked like a grand duke traveling incognito. Sometimes—earlier

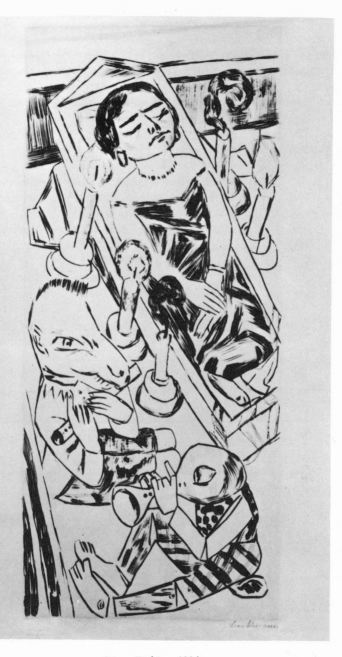

Dirge. Etching. 1924

on the Corniche Supérieure and now in the Bois de Boulogne—I observed that he suddenly blinked his eyes like a camera shutter, and I was not surprised when, several months later, I recognized that particular sight on one of his canvasses. I don't think that Beckmann did open-air sketches during those years; I know that his oils were all painted in the studio.

Many of the paintings which I had acquired were unsigned, which I regretted for practical reasons. In a German monograph on the master I read recently that shyness was the reason why he did not put his signature on many of his works. Just the opposite is true: he was convinced that his artistic emanations bore the stamp of his personality anyway, so he did not bother to spell it out. When I made it clear to him that in later decades art dealers and museums might need his signature as a guaranty for genuineness, he consented to affix his name. With brushes and paint tubes he came up into my apartment, signed approximately twenty canvasses and did some minor corrections. The way he signed his pictures through the years shows some changes indicative of his biography. From 1917 to 1935 he used the Gothic or German handwriting, very clear and almost schoolboy-like, in ironical harmlessness; usually his name is very visible as an integral part of the composition. Sometimes magnetic forces of attraction from the surrounding field seem to slant his script. But when he signed in my apartment, his handwriting had already become small, secretive; to accommodate his hoped-for international public, he now used Roman handwriting or printing. With the years his carelessness in this respect grew: some of the oil paintings are signed with a fountain pen, and the ink has already faded.

He did not mingle with the artistic crowd on the *rive gauche,* but occasionally he visited exhibitions of new works. He did not find much to his liking. Abstract art evoked his violent antipathy; experiments in this field he called *Krawattenkunst,* necktie art. "It is possible to do quite interesting things in the plane," he said to me, "but still, they always remain just two-dimensional. Wallpaper does the same. Tya." He preferred by far to stroll through the Louvre and the Musée Cluny, "avant-garding" for

himself and always discovering art which was new to him. Once I praised Cézanne a little too persistently for his comfort, and he interrupted brusquely: "Of course, of course. But at some time you'll probably get the message that I wasn't such a *Spiesser* (bourgeois)." One second of human weakness, perhaps jealousy.

Picasso was one artist whom he esteemed, and it was related that Picasso also called him *très fort,* very strong. Beckmann felt a competitive urge toward Picasso's art. "If one could only once hang our pictures together so that the people could judge for themselves!" he said. Many years later that wish was to be granted: in the New York Museum of Modern Art his triptych "Departure" hung opposite "Guernica," and many a visitor may have re-evaluated Max Beckmann during this juxtaposition.

We celebrated New Years Eve, 1938, in my apartment, and it was a memorable occasion. Madame de Porada had written a playlet especially for the event, a dialogue between spirit and world, which we recited to the company. We both wore masks. Kati, playing "Frau Welt," directed her verbal blandishments at me. My mask as "spirit," emaciated and stern, was equipped with a shock of hair which I, by pulling a string, made stand on end at the appropriate moments. The effect was excellent.

Beckmann sat in the center like an idol and emitted, from time to time, his smoky, rather high, short laugh. He had asked at the beginning that we serve him the champagne pure, not mixed into the punch which we others were drinking. Quappi wore a snowy-white evening gown; she looked enchanting with her sphinx-like eyes while she entertained us by imitating bird songs with her weightless soprano. My parents, brother, and sister-in-law sat around the flickering fireplace. My French girlfriend didn't understand much of what was said but she was impressed with Beckmann's personality. Later on, during World War II, she would save many of his paintings by hiding them in an old brewery where the German occupation forces, hunting for all refugees' possessions, never found them. A dealer in antique coins named Strauss, my father's friend, explained very thoroughly that he had studied all geopolitical factors and come to the conclusion that one of the Balearic islands was the safest spot on this globe. No world power

71

had an interest in this region, and he was going to retire there. Poor man, he could not preaict that a few years later Franco's police would arrest him on that exact island and would deliver him to the Gestapo murderers.

Worries and fears were forgotten when we toasted the new year of 1939. I believe we became pretty sentimental: we drank to art and friendship and to a better future.

Beckmann had the habit of always working on several canvasses almost simultaneously. Some he finished fast, others he revised after short or very long interruptions, until he felt certain that the final product expressed his intentions exactly. The lengthy process of painting and overpainting never had the awkward result that the fresh original conception was "painted to death." On the contrary, sometimes the very last brush strokes, applied to the thoroughly dried surface, added the most spontaneous vitality. Usually in his studio there was only one picture visible: the one on the easel. Many others were turned to the wall, some leaning in large stacks, a few standing singly so that he had but to whisk them around when his inner work had made some progress.

Entering his studio, you looked along the rows of puzzling white and brown canvas backsides, and you were too respectful to turn them around yourself or even to ask which was which. The painter himself silently selected what he saw fit for this particular visitor, put it up in the best light, inhaled with a mute questioning sound, and, after a while, said perhaps: "Pretty nice little picture, what?" If the response was not to his liking, he jutted out his heavy jaw; if he approved of the approval, he nodded thoughtfully and, in rare cases, elaborated or contradicted reticently, without verbalizing any deeper strata of the picture's meaning. Sometimes he said nonchalantly; "Tya, I guess you got this all right, my boy. You should really write this down. Quite interesting." He seemed surprised that one could formulate some mood, some relationship, some vectorial tension with words; he was pleased that, as a writer, one wanted to interpret his pictorial world.

When I inquired about the meaning of the half-blurred words

72

or names which had a largely ornamental function within a composition, he growled, "Well, these are some cosmic documents." With a little coaxing I succeeded in decoding a few, such as the "pinsky" on one of his triptychs: it localized the action in Berlin, at the Café Kempinsky. A directional sign "Sortie" appears incongruously in a painting of the River Styx with demons fishing for the souls which come floating by. "Well, just like in the *métro*," he explained: the Paris subway had produced a vision of the netherworld in him. He added some surprising implication to the assemblage of figures by affixing the inscription "Circus romanus" or "Im Anfang war das Wort" (in the beginning was the word) or "Saturn." A watercolored parrot croaks "An die ewige Dummheit" (to eternal stupidity), a monkey bellows "Eternity"; the same word, half hidden, appears ironically behind some almost burnt-down candles. A fragile, charming still life with mimosa blossoms receives a spiritual lightness from the name Voltaire on a book. The most typical words appearing on Beckmann's paintings remain, of course, Bar, Variété, Circus, Carnival, and the like: showing up the confusing phenomena as amusements for the ego. The writing is always graphologically integrated with the brushwork of each painting.

Beckmann detested showing unfinished paintings; he wanted to be alone and uninfluenced during the act of creation. However, I was present when he portrayed Madame Pomaret, who begged off coming to his studio: I had the honor of keeping still her little dog that she wanted in the picture. I also witnessed the progress of the portrait of my sister-in-law, Ira Morgenroth.

My own portrait, however, Beckmann painted from memory only. It was an especially long time in the making. We conferred about it in Paris in 1937. I commissioned it somewhat later, and I wished the Eiffel Tower to appear in the background. He laughed: "We'll see what we can do." Beckmann was not a man to whom one gave directives! When I grew a little impatient, he answered, "You'll have to wait, my dear, you haven't grown quite real yet." He always remained the master. In May, 1939 I paid for the portrait, without even having seen any sketches, and went to America. In his letters Beckmann referred to the portrait but refused to have it photographed before it was absolutely finished. It was only after the war, when we met again in Paris in 1947,

that I finally got to see my portrait: how young and idealistic it looked by now! He had given me a book to hold on which appeared the letters TIER and WEL, alluding to two of my publications *(Der Mensch ist kein Haustier* and *Das Welttheater des Malers Beckmann).* He referred to this portrait as "the protector of the book."

Portrait painting came natural to him; the additional incentive of a fee may have helped, in some cases. During some commissioned work he grumbled considerably. "Six fingers—tya, what the devil is he complaining about? Six instead of five for the same money—" But he dutifully undertook the removal operation. After many pencil and charcoal sketches of a not-too-inspiring sitter he groaned, "I don't know if this will ever be something." But then came a propitious hour, and the result was something.

It happened several times over the years that a subject grew into the formula which Beckmann had preordained for him or for her. His portraits were really a task to live up to. He could not start realistically; he first had to put the sitter into some context of the "passing show." Thus he has grouped people together in lively conversation who in reality never met, or who were enemies by the time they were united on one canvas by Beckmann. He needed the varying characters—in his terminology—as split-off emanations of his Atman: as kaleidoscopic variations of the ego which, to him, was identical with the world-soul. In this way, the portrayed ones became functions of his self-realization, and in subtle camouflage we finally reappeared in the pageants of his triptychs. We just had to play a role for the stage director, and that wasn't so little, after all.

Early in his artistic career, while he was a medic in World War I, he wrote to his first wife Minna: "Meeting people is, to me, wonderful. I have a crazy passion for the human species." This direct contact became subdued and complicated with the passing of the years. In personal relations he grew reticent, even grouchy. He was glad that Frau Quappi, with her natural tact and open heart, evened out the rough spots in life's journey. His interest in humans did not express itself in so-called good manners. His friends felt it when the atmosphere around him was sympathetic

and friendly; they tried to dispel his solipsistic "blues." And sometimes, when a situation made sense to him, when the people were grouped like a good picture composition, when he saw a first-class cabaret performance or when he was a guest in a friend's house, he could be very good company indeed, witty, considerate, and sparkling with ideas.

And this way, as he was in his best moments, he appears to me when I think back over the years.

In April, 1939 my family and I booked passage on the French liner *Paris,* which was supposed to bring us to America. A few hours before we were to take the train to Le Havre, we heard over the radio that the *Paris* had burned in the harbor. I was desperate, thinking that my luggage, which included Beckmann's paintings and my manuscripts, was lost. Soon we learned that, thanks to some blessed inefficiency, our possessions had not yet been loaded on board. This initiated a chain of adventures through which these masterworks were to survive the cataclysms of World War II.

A few days later we traveled on another boat to New York. The separation from my great friend naturally gave me some pain. I received beautiful letters from him, however, which were a compensation. He addressed me, at the time, by my middle name.

17 rue Massenet, Paris, April 26, 1939
My dear Ernst, thanks cordially for your friendly letter. I too was sorry not to have seen you any more, and I must confess that I miss you a little—decidedly. But some person-al collaboration will surely occur again, and I'm glad that it will. You must have gotten some humorous thrills from the burning of the "Paris." Perhaps you can use some of this in your writing. I believe anyway that the big trip will give you a new outlook. I look forward eagerly to the results.— I accept gladly your proposition concerning your portrait. I'm certain that it will be a good piece of work.— I am writing you on a day of good omen, firstly the conscription

in England and secondly, almost at the same hour, my "Carte d'Identité." At last! So I'll move to Paris, and I'll be able to unfold new, intense powers here since* la France *has taken me into her motherly arms. The stay at Cap Martin has benefited me greatly and colored all my ideas anew. Absolutely new things have come into my ken, and I'll have to work twenty years to realize all this.— When you see our common friends, give them my best greetings and tell them that we have* not *resigned and that the spiritual Germany will again take its rightful place among the peoples. We are* at work.

Always your Beckmann
Greetings to your parents and brothers.

On May 22, 1939, he wrote me again from Amsterdam.

Dear Ernst, many thanks for your letter and check which just reached me before I left Paris. Now I'll stay for two and a half months in Amsterdam, then the move to Paris shall take place. Before my departure I still finished your portrait. I believe it turned out very well. But I don't want it to be shipped or photographed just yet since I wish to inspect it once more before releasing it. I would have a disagreeable feeling if it should be immobilized too early. Where might this letter reach you, in New York or already in Detroit?

Here, I am intensively working on the new triptych number three; this will be a crazy story and gives me a heightened feeling of life, an enhanced life . . . I will see Valentin here still. Did you see the Barr exhibition in the Modern Art where my first triptych is shown? I would be interested to know how you liked it, as well as further impressions from your journey. Write me soon about that.— Please send the next monthly check here, I'll have it

*This was an indispensable paper if you wished to stay and work in France.

76

exchanged at the Amsterdamsche Bank. Very cordial greet-
ings to the Detroiters and to all acquaintances.

Always yours Beckmann

The "Detroiters" were Bernhard and Cola Heiden, the com-
poser and his pianist wife who were among Beckmann's best
friends. The planned move to Paris never took place; Beckmann
remained in Holland until 1947.

On July 3, 1939 he wrote me a postcard which is so character-
istic for his way of tackling life that I'd like to render it in the
German original, as well as in translation.

Lieber Ernst, Dank und Gruss für Sendung. Bin in
äusserster ARBEIT.— Le nouveau Trois steigt aus dunklen
Gewässern über Sekt, Cadaver und den kleinen Wahnsinn
der Welt empor zu äusserster Klarheit.— O mon Dieu, es
lohnt zu leben.

B.

Dear Ernst, thanks and greetings for the communication.
I'm utterly submerged in work. Le nouveau Trois rises from
dark waters, up over champagne, cadavers and the little
madness of the world to final clarity. O my God, life is
worthwhile.

B.

"Le nouveau Trois" meant his new triptych "Acrobats," which
now belongs to the State University of Iowa. Champagne and
cadavers are only moody metaphors, but the "little madness of
the world" is not. The few sentences give a reflection of Beck-
mann's extreme state of elation, almost of intoxication, while he
was creating. One can't imagine an impressionist, for instance,
erupting this way on a postcard!

Beckmann also kept up a correspondence with my father,
whom he considered a friend. My father was a collector of Re-
naissance art, mostly of medals and plaquettes, and very knowl-
edgeable in this field. My enthusiasm for Beckmann's art had

infected him to the degree that he and my mother had acquired several of his works. My father worried about the fate of the artist and inquired about his plans. On October 18, 1939, Beckmann answered:

Yes, we are glad to be sitting here in Holland while outside thunderstorms are descending. It seems improbable to me, myself, that in spite of the horror and madness of these times I can still work intensely and well, and that I even find people who are interested in my work and help me along. You know well whom I'm primarily thinking of. One can surmise now that our just cause will slowly gain victory, though we'll still have to suffer a lot. It would be beautiful if we could succeed in meeting again in that Germany which we all love. Until then we'll just have to carry on, and I hope not to disappoint you and Ernst by what I will still produce . . . I am inclined to hope that Holland won't be occupied. As long as I'm free, I will not cease to formulate what I think is right, and to serve the truth in whatever way I can. With best regards to your dear wife, I remain

<div align="right">

always your
Beckmann

</div>

Many Greetings to all also from Quappi.

<div align="right">

Amsterdam, November 20, 1939

</div>

Dear Ernst, thank you very much for letter and check. It is always a joy to hear from you, not because of the money, but because it reinforces the feeling of a metaphysical predestination between us. A somehow amplified symbol for fateful necessity: it's exactly these things which I pursue with a certain sportive interest, because they are extremely rare, like gold veins or diamond finds. Nonetheless they exist, and the net of enormous, unknown calculations in which we are caught up becomes almost visible, sometimes.

The war makes them evident in other ways, too. I'm writing this during a blackout in Amsterdam, to the harmo-

nious concert of wailing sirens. One must admit that un-
known stage-directors try everything to make the situation
more interesting, in the sense of a penny-dreadful. Critically
we must state that, unfortunately, they don't have many
new ideas any more, and that we have now the right to
stage something new. And that, after all, will occur sooner
or later. I, for my part, am busily preparing new stage sets
among which the play may go on.

I'm sorry that you don't write more about yourself and
your work, I'd like to know more about it. Is New York
amusing, in the long run? Or would you think that one
could produce more essential things in a cleansed
Germany? At any rate, I derive great pleasure from my
work and, to my own astonishment, I have not only new
inspirations, but the feeling of being essentially at a begin-
ning becomes daily stronger. Maybe this stems from my
very much improved health, I feel much better than at that
time in Paris. The war seems to agree with me, for I see a
new world emerging, "ice cold out of fiery fevers."—One
has to reckon in very large time complexes which transcend
by far our short lives. A chain of developments extends
over many millions of years. In these we have to personify
one actor, certainly individualized, but boundlessly versa-
tile, whose task it is to represent the actual stage of exis-
tence.—

But I don't want to digress too far, since I really
intended to write you a matter-of-fact letter. Well, there are
many paintings left at Poyet's gallery, under Kati's supervi-
sion. It would be best if you would order a list of these or,
better still, if you would have them photographed by Marc
Vaux in the rue Vaugirard. The paintings which you will
select from the photographs may be shipped to you rolled
up in a cylinder . . . Politically things seem to be all right,
events now take their course, which will require some time.
Here everybody was very nervous for a while, but this
seems over now. I'll write to Valentin as you desire. My
best wishes to you, my dear, above all for concentration in
your work. Write me more often about your life in New

79

York, it is always a joy to hear from you, and it also
strengthens me.

"Herzlichst" Ihr Beckmann
Greetings to the parents and all others, also from Quappi.

My father had found the New World very much to his liking;
fearing the worst from the "madman" Hitler, he worried about
friends and relatives who had remained in Europe. Especially a
man hated as much by the Nazis as Beckmann was should not
stay behind! He corresponded with Beckmann about various
possibilities. This is Beckmann's answer of November 30, 1939,
from Amsterdam, to my father:

. . . It was very kind of you, your dear wife and Ernst to
think about my fate and to consider transplanting me again.
Since I have to reckon objectively with a longer duration of
the war and with various dangers for Holland and thereby
also for myself (such as internment etc.), it seems entirely
clear that a change of domicile would probably be best for
me. Besides, America is that country which offers me the
best prospects for success and acknowledgment, as long as
Germany is not rehabilitated again in our sense. Thus I
would very much like to go. Yet great difficulties are piling
up already. We inquired at the American Express today: it
seems very hard to obtain a visa, even a tourist visa. They
also told us that several times Germans were taken off by
the English from Dutch boats, which is not an agreeable
outlook. Anyway the Dutch line cannot and will not guar-
antee anything. And, lastly, I don't have the slightest idea
how much, if indeed any, financial means would make my
living over there possible, and whether I could find a good
job. Naturally it would be wonderful to be able to work
again without the eternal fear of war danger and similar
worries. Besides, New York and surroundings might offer
me great stimuli. Furthermore it would be nice to see each
other sometimes, I still remember with pleasure the lovely
hours we spent together in Paris. To sum up: if fate wants it
so, I would be ready to accept all dangers and restrictions in

*order to bring my work—which I consider still unfinished—
to a good conclusion. I would regard this as my duty
toward the mission to which I am called.—*

*I am glad to learn that Ernst is married agreeably and
nicely, this is certainly a great advantage for his life and for
his work which shows much promise. I'd like to look at his
new literary production if this could be arranged occasion-
ally.— I hear from Valentin quite often, he wants to exhibit
my work at the beginning of next year. In case of my
immigration, he also could be helpful through his connec-
tions with Barr, Mrs. John D. Rockefeller, Swarzensky, etc.
However, I don't know yet what fate will decide about me
in these matters. At any rate I thank you very cordially for
all your interest in my person, and I only hope that in the
future I shall have the opportunity for some recom-
pensation. Best wishes to your dear wife, Ernst and the
children, also from Quappi.*

Yours, Beckmann

Europe was indeed becoming very unattractive for modern
artists.

There was, for instance, the infamous sellout of German
museums' property that took place in Switzerland. The German
government wanted foreign currency for imports needed for
rearmament. So, after first having confiscated all "degenerate"
works from the museums, the Nazis shipped the most valuable
ones to Lucerne: if foreign museums and collectors were stupid
enough to pay Swiss and French francs for this "garbage," so
much the better for the Reich. The catalogue of the Galerie
Fischer in Lucerne, who handled this auction on June 30, 1939,
looks today like an art compendium of incredible richness. The
prices paid were somewhat higher than expected, but compared
to today's art market they were pitiful. Chagall's "Rabbi" went
for $380, Klee's "Roadside House" for $200, Kokoschka's
"Trance Player" for $490. Beckmann's "Masked Ball" of 1925
brought $220, his "Self Portrait" of 1917 only $120! And so it
went: 125 items of the highest caliber for a total of 650,000
Swiss francs. When the German museums bought back some of

81

their treasures in the fifties, they willingly paid prices ten to thirty times as high.

One unwelcome side effect of this and similar "fire sales" was that the museums hardly purchased works directly from the artists any more. I don't think that Beckmann sold a single painting during those years to a European public collection.

In contrast, America seemed to beckon with rays of hope. Curt Valentin sold several Beckmann pictures, and his New York exhibition of January, 1938 went on tour to Kansas City, Los Angeles, San Francisco, Portland, and Seattle; the critics were friendly and understanding. In the spring of 1939, the director of the Art Institute of Chicago, Daniel Catton Rich, invited Beckmann to teach there during the summer semester. In July, 1939, his triptych "Temptation" received the first prize of the foreign section at the Golden Gate International Exposition in San Francisco, carrying a remuneration of $1,000. J. B. Neumann and Curt Valentin tried to smooth his path to the United States.

However, bureaucracy interfered. Mrs. Quappi Beckmann wrote me much later, not without bitterness: "The only reason why we did not come was that the American Consul at the time, after two visits in The Hague, refused us a visa. As his reason he stated that war was certainly going to break out, and in this case (after the summer semester at the Chicago art school) Max would be without means and would be dependent on relief from the government; he, the consul, could not take this responsibility upon himself! All assurances on our part that this would not happen, our presentation of the best references and written guarantees did not change the consul's obstinate refusal . . . Had we obtained the American visa in May 1939, Max would have been spared much suffering, and perhaps he would still be alive today. His heart ailment began during the first war years, in 1942, I believe. Anyway, I can assure you that Max would have been only too happy to come to America at that time, and that he was joyously eager for the teaching job which Mr. Rich had offered him . . ."

After the war broke out in September, 1939, Beckmann had to give up his plans concerning Paris or America. He soon resigned himself to stay in Amsterdam indefinitely; and, to tell the truth, he was glad to have found a haven in Holland.

I continued to fulfill our contract. Every month I sent money from America to Amsterdam, even though the possibility of receiving paintings for these payments became more and more illusory. The transfers were complicated by increasingly restrictive rules and regulations concerning mail and banking. My last, telegraphed, transfer, effected on May 8, 1940, still reached the painter. Two days later, on May 10, the German armies invaded neutral Holland, which capitulated after five days.

Thus my connection with Beckmann was severed. For five years his American friends had not the slightest bit of news concerning his health and activities; we didn't even know whether he was still alive.

In the United States, meanwhile, Beckmann's artistic reputation kept growing even though the country had enough other problems besides understanding modern German art. When Curt Valentin held his first Beckmann exhibition in New York, the *Magazine of Art* wrote (in February, 1938): "Beckmann has abandoned the distorted violent subjects of post war years. He has come through this period of bitterness and frustration and has apparently found spiritual release which his more ordered if no less compelling compositions reflect . . . The triptych which is the high water mark of his achievement is a confession of faith—a summing up of his philosophy of life."

One of the next Valentin exhibitions was reviewed by the *New York Times* on January 7, 1940: "Beckmann is as uncompromising as ever, but his style has mellowed somewhat . . . The pictures have terrific impact. One feels that they are the offspring of a soul that has passed through darkness and despair and has faced unflinchingly a world of largely alien values." And the *Art Digest* wrote about that same exhibition: "Beckmann has given visible form to philosophic concepts that mark him as unmistakably Germanic . . . The artist plays his color organ with the fortissimo stops open wide."

On May 4, 1941, the *New York Times* brought a very favorable review: "On the creative side, this artist remains a German expressionist; an expressionist of power and originality." *Time*

magazine also mentioned him on June 9 of that year as "an 'Aryan' expressionist regarded by many, before Hitler, as Germany's No. 1 painter." And again, on January 12, 1942: "Max Beckmann, Germany's greatest living artist (before Hitler), was packing to leave Holland, teach at the Chicago Art Institute, when invasion swallowed him in the spring of 1940. Last week Chicago gave missing Max Beckmann his biggest one-man show in the U.S., at the plush-lined, modern-art-conscious Arts Club . . . Many canvasses, obscurely symbolic, writhed with brilliantly colored male and female figures, with fish and anthropomorphic bric-a-brac in a Freudian *Walpurgisnacht.*"

Half a year after Germany had declared war on the United States, the Museum of Modern Art in New York exhibited "Free German Art" that it had recently acquired: Beckmann, Barlach, Kollwitz, and Nolde. In the midst of a bitter struggle, the objectivity with which this show was received was truly astounding. None of these artists had come to America; two of them were still living in Germany. Yet, the reviewer of the *New York Times* could write on June 28, 1942: "Mr. Barr refers to the pre-Nazi German school as 'second in Europe only to that of Paris.' And yet I found myself accepting some of it on terms of perfect equality with the best that the Ecole de Paris has produced . . . Max Beckmann's large triptych 'Departure' has entered the Museum of Modern Art to stay . . . Mocked though we may seem to be in our effort to work out some sort of precise allegory of bondage and release, the strength of the impact remains unassailable."

How I regretted not to be able to send Beckmann these reviews! All I could do was to further his growing fame by lending and exhibiting paintings which belonged to me and which I had brought to America: "Temptation," "Brother and Sister," "Self-portrait with the Horn," "Sacré-Coeur," and many others. Even the triptych "Departure" was, to fifty percent, my property, and Valentin asked jokingly which of the captive women were mine.

The last transport of five Beckmann pictures, coming from Basel, reached me in California on September 25, 1941, after an odyssey of several months. Beckmann's oeuvre seemed almost

84

eerily indestructible, compared, for instance, to the work of Carl Hofer, which was almost totally destroyed by Nazi confiscations and by Allied bombs, or to the "degenerate" works of art which fell victim to the Nazis' mania for "final solutions": 1,004 oils and sculptures, 3,825 watercolors, drawings, and graphics were burned in one auto-da-fé in March, 1939, in the courtyard of the Berlin fire department. As far as I know, only one important Beckmann, the "Queens" of 1939, was lost through fire in Munich; some, belonging to Karl Buchholz in Berlin, however, disappeared in the wave of looting at the end of the war.

Together with my young wife I had moved to Santa Barbara in California. On the wooden walls of our little house we hung five or six Beckmanns; there was no wall space for the larger ones. When visitors came they looked at these paintings apprehensively: "Who paints in this house, you or your wife? " Two exhibitions in the local museum, one radio conference: that was all the traffic could bear.

I was married very happily but otherwise not bedded on roses. My English was not good enough for a writing career. Still, I published short stories and articles in Switzerland and South America. Being a so-called enemy alien, many lucrative jobs were closed to me by law, and every night after eight o'clock I had to be home under curfew. I worked on a lemon ranch, watering, pruning, destroying gophers, and driving a tractor. The latter aptitude got me into a tank with the 13th Armored Division, and soon I found myself in Lorraine and finally back in Germany.

I cannot relate personal memories of Max Beckmann between 1940 and 1945: we were separated, first by seven thousand miles of land and sea and then by bloody front lines.

Today it is possible for the interested reader to close the gap by studying Beckmann's diaries from those years. Several German friends of the painter have also reported on his life in occupied Amsterdam. It is a strange paradox that Beckmann, *verboten* by the Nazi authorities, was clandestinely supported by Germans. Lilly von Schnitzler, Doktor Göpel, Helmut Lütjens, Günther

Franke, and Karl Buchholz helped him secretly and bought his paintings; this certainly required courage and devotion at the time.

The most positive result for Beckmann of the otherwise dismal world events was a renewed relationship with his son. I met Dr. Peter Beckmann after his father's death, and we had many instructive and nostalgic conversations about the man whom Peter simply called "Max."

Peter was Beckmann's only child. Due to the divorce from his first wife Minna, the two had only little contact. In an autobiographical essay which Max Beckmann wrote in March, 1923, he mentioned matter-of-factly: "In 1908 Peter Beckmann was born. A promising youngster. From time to time I take spot checks of his development which interests me much." Now the matured Peter suddenly appeared in his father's house in Holland, as a staff physician of the German *Luftwaffe*. Peter selected paintings in Amsterdam and, contrary to the interdiction of all "degenerate art," smuggled them back into Germany. He was stopped at the border, soldiers inspected the strange pictures distrustfully, but Peter reassured them: "These I have painted myself as a joke, don't you see, it says Beckmann right here." The simple souls let him pass with his unrecognized treasures.

Peter repeated this trick several times. In August, 1942, he even brought the huge "Perseus" triptych in a German air force truck to Munich, where Günther Franke bought it; this is the only one of Beckmann's nine powerful triptychs which remains in Germany today, the eight others being in America.

Max Beckmann's diary was edited by Mathilde Q. Beckmann and Erhard Göpel and published by Albert Langen-Georg Müller in Munich. The writer did not intend it to be printed in this form, but the lack of literary polish makes it a highly personal and lively document. A few excerpts should give the atmosphere of the book and of the times.

M*ay 4, 1940.* I start this new notebook in utter uncertainty about my existence and about the state of our planet. Chaos and

confusion wherever you look. Absolute enigma of things political and military.— (Yesterday and today England left Norway again where it had landed with an unspeakable effort against the Germans.) America is waiting for me with a job in Chicago, and the local American consulate won't give me a visa. Besides, seven paintings are, on approval, at the Stedelijk Museum which has not bothered about me for three years. Apart from that I made my first large bicycle tour today with Quappi near Hilversum which was very beautiful in full brilliant spring. In spite of everything, it isn't easy to hold one's head high, and it is really a miracle that I still exist at all.

For what punishment and terror, or for what joy and merit have I been spared by my own Karma?

One thing is certain, pride and spite against the unseen forces shall never cease, may come what may, even the worst.— I have strived all my life to become a kind of "self." And I'll not deviate from this, and there won't be any wailing for pardon and pity even though I should fry in flames through all eternity. I, too, have a right.

May 6, 1940. After all is said and done, I am becoming indifferent. Lived too much and too long in misfortune and anonymity. Saw the old worlds slowly go to pieces, and I can't possibly adapt myself to the new upcoming world of regimentation. The difficulty is only how to get off board.—It is sad to be trampled so slowly by fate; but after all, since I strove for years to make illusions and irreality appear, should I be afraid of the awakening?

May 7, 1940. War will certainly come to Holland too (all reserves have been called up again)—and then I'll be imprisoned and shall croak there, or I'll be hit by the famous aforementioned bomb.— Well, it's all right. If it only happens fast—and to me alone—

It's a pity, though, I really know how to paint pretty well. But perhaps I've accomplished enough—"

Most of the daily jottings give accounts of the progress of his

87

work, of visitors, of everyday problems like freezing cold, air raids, wartime rumors. Short remarks about what books he read and what meals he ate, about hunger and sickness and inspired hours make this a picturesque account of a halfway-underground existence.

Strewed among the sometimes banal documentations are philosophical explorations of Beckmann's inner world that seem to rip open enormous perspectives. The painter's most characteristic paragraphs, written in 1940, are the following:

> *Every good painting must, without difficulty, blend into good architecture. This is almost a test for the picture's quality. As soon as the illusion of space goes beyond artistic necessity, even by a nuance only, it breaks up the picture plane and, therewith, the chief artistic law which excludes nature reproduction. Of course there are many cases of pictures where the plane is excellently preserved and which, nevertheless, are bad pictures because of the lack of original invention. The highest form of suggestion appears only where a feeling for nature and picture plane have been welded into one unit which procures the illusion of space within the plane.*
>
> *This is the metaphysics of the material.*
>
> *The strange sensation which is suggested to us when we feel: this is skin—this is healthy—this is bone—within a vision which is absolutely extraterrestrial. The dreamlike quality of our existence together with the unspeakably sweet sheen of reality.*

The only emotion which is completely lacking in this war diary is hatred. Beckmann's sympathies were clearly on the side of the Allies; like the Dutchmen around him, he awaited the invasion impatiently; and yet, when Germany was in full defeat, he expressed no feeling of triumph, only sadness about the destruction of the continent.

Beckmann was above any narrow nationalism. In 1914 he had said to Peter's mother: "I will not shoot Frenchmen, I have learned so much from them. And not Russians either: Dostoevski is my

friend." He remained true to his conviction all his life. When war surrounded him for the second time, hunger and bursting bombs were not the only horrors: the senselessness of the general slaughter was, to him, equally terrible. Of course, he greeted the liberation jubilantly; but on March 10, 1946 he wrote the tragic sentence: "Everything is more nationalistic than ever, and all my efforts for a common humanity are more forlorn than ever."

The diary of Beckmann's war and postwar years was not published until 1955. The rather clear picture which it conjures up of those times still does not supersede the vacuum of our friendship between 1940 and 1945. The missing Beckmann, like a huge hole in my world, had taken on the character of a fearful ghost.

When you leave a mountainous region by train and look back through your window, a curious metamorphosis of the view takes place. At first, while the train winds its way through the foothills, you tell yourself: I must not forget this lush meadow here, that little stream where I caught the big trout, that charming hill. As you gain distance, other peaks rise into view. Snowy, forbidding summits reach for the sky, and slowly you recognize their true stature. But finally just one distant peak seems to dominate the landscape.

Max Beckmann's art is a craggy, lonely, forbidding peak which seems to loom higher as time goes by.

I would have liked to search for Beckmann in Europe, but General Patton had other plans for me than sending me to Amsterdam.

In the summer of 1945 my division was shipped back to America, and we underwent amphibious training for the planned invasion of Japan. Luckily, this took place in Camp Cooke on the California coast, so I could see my wife and parents occasionally.

As soon as private mail functioned again I wrote to

Beckmann's ancient Amsterdam address and was surprised to actually receive an answer. Suddenly there he stood again before my eyes, the old magician, with his ironical tolerance of humanity's foibles and follies, with his strange mixture of otherworldly fatalism and vital appetite for existence.

Amsterdam, Rokin 85 - 27 August 1945
Dear Stephan Lackner (Quinientosstreet)
Ah—well. There you are living. Amazing to hear from you and California. The world is rather kaput, but the specters climb out of their caves and pretend to become again normal and customary humans who ask each other's pardon instead of eating one another or sucking each other's blood. The entertaining folly of war evaporates, distinguished boredom sits down again on the dignified old overstuffed chairs. Incipit novo cento No. 2—

Well, my dear, you must have experienced quite a lot and I am curious how you will use it in your work. It is regrettable that you couldn't materialize here at the Rokin as an American archangel Gabriel. The effect would have been first-class, and I had more or less counted on it. Well, now the angel has turned into an airmail letter, which isn't without charm, and leaves ample play for fantasy. I gather from some hints in your letter that you are still married and that your dear parents are well. I'm glad to hear both. I find it amusing that in Paris you rediscovered your girlfriend as a grandmother and some old Beckmann paintings. By the way, three or four pictures are still standing around here which belong to you, according to our old agreements at the beginning of the war.

May I report about myself that I have had a truly grotesque time, brimful with work, Nazi persecutions, bombs, hunger and always again work—in spite of everything.— I've painted about eighty pictures, among them four large triptychs. The titles are: 1. Acrobats, 2. Actors, 3. Carnival, and 4., finished only eight days ago, Blindman's Buff. I think some of it would give you pleasure, for you know a lot about me.

Classical Park. Drawing from Goethe's "Faust." 1943

My situation at the moment is this: through the intervention of Professor Ruell, the director of the Rijksmuseum, I can stay here at least until November, in spite of my still being a German—unless a wave of superpatriotic Dutch feelings should succeed in shipping all Germans without exception back to Germany. This possibility, concerning me, amounts to no more than ten percent. Nonetheless it would be very good if something could be done for me from America, through some kind of an affidavit, a request to fill a teaching position or anything. It would be regrettable if now I would have to go back to Germany, because then any communication with other countries would become extremely difficult. Please think these matters over, perhaps together with Valentin or Swarzensky who, I believe, is in London right now. I am on tenterhooks to know how everything will turn out, and I hope to hear from you soon again. My nerves and capacity for work are stronger than ever, and I hope to go on producing essential things.

Very cordial greetings, also from Quappi (who is all right).

<div align="right">

Yours,
Beckmann

</div>

I was still a soldier in Camp Cooke.

Then the atom bombs fell, and the war was over. Our colonel showed us on a classified map of Japan the stretch of sea coast which our 13th Armored Division had been slated to conquer, and I was released from the service.

From the ensuing intensive correspondence I want to quote those letters of Beckmann's which throw a sharp light on his circumstances and character.

<div align="right">

Amsterdam, Rokin 85—7 October 1945

</div>

Parcel with edibles arrived—turkey pâté wonderful. Everything else extraordinary. Deepest gratitude assured. Further interest in cigarettes vital, for furthering artistic production.— Necessity to have studio in Chicago, Santa

Sirens. Drawing from Goethe's "Faust." 1943

Barbara or Charlestown, urgent because America needs a certain pepping up.— Danger of mass unemployment combined with dollar inundation very great. One should also consider Stalingrad or Moscow concerning erection of larger edifices with murals among which to enact the spiritual productivity of the United States of the World.— This in passing only.

Outside the sun is shining—agreeable. It's turning cold—one will freeze—never mind. Worked last year at four degrees centigrade all through the winter. In the next days circa forty drawings will be sent to Valentin. A little rounding-out of the Beckmann panorama. Will probably give you some fun.

Are you still a soldier? How is your work going? Today only hurry telegram style. Must get to the picture. Let me hear from you soon

Always your Beckmann

Hope you received my first letter.

Amsterdam, 12 January 1946

Dear Stephan Lackner, thanks for your detailed letter of January 2. Well, we can't help it, times are becoming more normal, so business requires our attention again. It seems strange to talk about such things again because in the intervening long period I ceased completely to think about these matters. Thank God that you kept everything so well in mind, and I believe that all is correct as you write it to me which I herewith gladly confirm. Thank you for your generous action in the case of the triptych "Departure." Please hold the $500 at my disposal until further notice, since I don't know yet exactly what will come to pass. The four or five paintings which you bought from photographs are assigned to you . . . I also agree to the other acquisitions of paintings Death, Apache Dance, Barge, Woman in Bed, Beach, Greenhouse and five water-colors. Thus a good settlement of our accounts up to now should be accomplished.— Thank you also cordially for the gift

94

parcels which always bring much joy and which, unfortunately, are still very necessary because the slow relaxation of rationing makes all goods still very scarce.

About the development of the European art market not much can be said since it just starts taking shape following the opening of the frontiers. Germany is still excluded. But this will change, and then Germany will have to assume the role of a buyer.– Today seventeen paintings, including a new triptych, have been shipped to Valentin–thank God, what a lot of work–and now events will take their course. Consequently I am very gay and painting again with all my might.– Nice that you and your wife, whom I am eager to know, intend to come here. Let me hear from you again very soon. Greetings to the parents and all good wishes

Yours, Beckmann

Amsterdam, 28 March 1946

Dear Stephan Lackner, yesterday I just wanted to write you but didn't get around to it, and today two parcels arrived from you, from January and February. Many cordial thanks, it is always very agreeable to get some supplements to the still sadly restricted rationing, and your parcels are always composed with great insight and refinement. Since you mention four parcels, I presume the two missing ones will still show up. If you feel like sending something again, I would be grateful also for cigarettes. They are almost unobtainable here which is a cause of suffering to me.– I won't get to Germany soon, because, for me, an exit to America would be easier than to Germany. We are not even allowed to write to Germany, and vice versa. I'm happy that you like my new works. I believe that they are not bad, but I'd like to show you my latest ones–Sad that you aren't here.

I'm working under great pressure. Much must still be done before I can lay down my weapons. I'm glad that you also are working hard, and I'm convinced of good results.– Valentin seems to be already very successful with my new

*works. I'm happy about this, especially with regard to all of
you who have always so strongly helped me.— My wife is all
right except for the aftereffects of a concussion of the
brain. Recently she fell down one of those disgustingly
steep Dutch staircases.*

*I'm deep in work so today am brief, but I wanted to
thank you right away.*

<div align="right">

Cordially yours Beckmann

</div>

The paintings mentioned in the letter of January 12 were
exhibited for the first time at Curt Valentin's Buchholz Gallery in
New York from April 23 to May 18, 1946. They were received
with greatest interest by the press and the public; and, very
importantly for the painter, the exhibition was sold out except
for three pieces! Valentin sent me his catalogue with eight
illustrations, and these were my first glimpses since 1939 of
Beckmann's continued development. Among these were the
"Young Men by the Sea" (1943), "Café in Bandol" (1944),
"Dutch Women" (1945), and "Self-portrait" (1945). I wrote an
enthusiastic letter to the artist. Here are some notes which I
jotted down under the impact of the first impression.

"To his friends in the United States Beckmann had, for years,
become a myth—perhaps even to himself. Nobody knew whether
he lived, painted, suffered. And now seventeen new paintings
arrived, greetings from Atlantis. Surprising but organic
development. The nightmare he had known before is integrated.
Now tremendous affirmation. Quieter, perhaps more
self-contained, humans don't shout any more. Four men sit
conspiratorially around a table, Beckmann with cigar and
self-mirror, one in a fur cap has brought a fish, another one bread,
symbolic candle in the center is reckoned as a comfort. Memories
of Southern France in lovely prewar times, captured in speedy
transit. Unforgettable condensations strong as a dream.
Self-portrait: only the most essential, no bellifications, serene and
pulled-together. The manliest painter.

No doubt: the United States has his most beautiful paintings
today. The Germans, in incomprehensible incomprehension,
damned him as un-German, just as they condemned Barlach,

Myth. Drawing from Goethe's "Faust." 1943

Hindemith, Thomas Mann. Beckmann is typically Germanic like Bach and Dürer: always knowing about death and still singing life's praise: the art of cathedrals. Submergence has not diminished him, he emerged again from the depths as a master."

Eagerly I collected press notices. For twelve years it sometimes seemed to me that I, together with a pitifully small group of faithful ones, only imagined the significance of this art. Now *Art News* of January 1, 1946, grouped Beckmann together with Picasso, Rouault, and Chagall as "classic Europeans." And *Time* acknowledged on May 6, 1946 that Beckmann was "Germany's greatest living artist." Whenever I had said the same in earlier years, the response had been, at best, a polite smile.

How did Beckmann himself react to this change of fate?

His diary entries from those weeks show that exemplary strength of character which enabled him to combine his high-strung temperament with a distrustful self-control in unlucky circumstances. The elements of his nature were strangely mixed from romantic effusion and skeptical "coolth." On January 12, 1946 he rhymed a cynical ditty (freely translated):

> *The pictures are swimming*
> *from Rotterdam*
> *nobody is winning*
> *no one gives a damn.*
> *Should they arrive,*
> *the eternal stupidity*
> *will swallow them up*
> *with childish cupidity.*

The diary transmits the excitement of March 26: "I shall be interviewed— *oh mon Dieu*, Saturday, I believe by the New York Times—well, one has to go through with this, for a change. Perhaps a period of gigantic success—oh how humiliating."

The entry of May 2: "Success, nonsuccess, madness and boredom flood me from above and below. Fifteen years ago I was more amusing. Especially to myself." On May 9 he has regained his equanimity: "Nothing matters except work.— I was pictured and reviewed in Time. Rather ridiculous, but—the toilet attendant

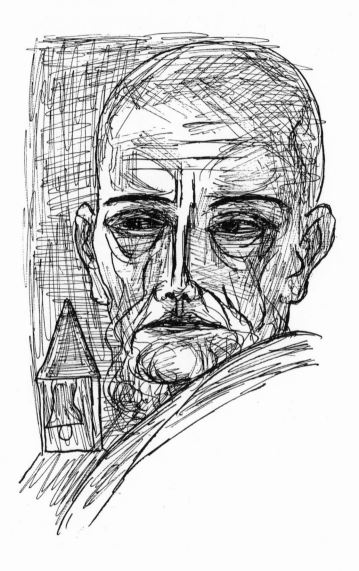

Faust in Old Age. Drawing from Goethe's "Faust." 1943

in Chautauqua must get something for her money, too."
Beckmann and I made plans for a reunion, but we had to be patient.

Laren near Amsterdam, 26 Mai 1946
Dear Stephan Lackner, thanks for your letter of May 16.
Yes, it really seems that things are picking up—but the main
purpose is and remains always work, for its own sake.
Essential for this are health and strength of nerves. To
further both I find myself in the country for a thorough
rest, which isn't so very simple either. Laren at this moment
is, in spite of everything, absolutely grand, a fantastic
springtime, better than in years. For me this is a kind of
paragraph in life. For three years I had not left my studio in
Amsterdam, and I feel transported into another time. But
nice.—

You ask me about new prices for paintings. God, this is
hard to determine, but I'm convinced that we'll always
come to an agreement when you intend to acquire
something by me.

There's always great joy when a parcel from you arrives,
and we always admire your skillful selection. "Smokables,"
however, we have not received until now. I would be very
grateful for a few cigars. Customs complications are minor
and don't take very long . . . Valentin has announced his
arrival here for July, according to the latest bulletins he
might come even earlier.

I'm glad that your writing is progressing well. I'm
curious how it will look. Title "The Engineer and the
Mermaid" seems good, though the concept of technology as
such gives me the creeps and the mermaid picture generates
pale associations with early romanticism such as Schwind.
But then, one would have to know the book. It might be
very good.— It is altogether faulty that we don't live close
to each other. We could see many things more clearly and
stimulate each other more strongly.— Don't forget that you
haven't drunk a truly noble champagne with me. That has
to ensue some time. Then we'll have much to say to each

100

*other which cannot transgress inhibited tongues into the
sound-world of day. Anyway I'll be full of joy when you
come.*

Always your Beckmann

Amsterdam, Rokin 85. 4 August 1946
*My dear Lackner, I have to thank you again for a splendid
parcel. I'm again deeply touched by your care and the lard,
chocolate and tobacco wares. Here everything is still
rationed and very scarce.— Meanwhile Valentin was here
and has made a huge purchase of pictures. He is a fine man,
and our business is in good hands with him. We have given
you cordial thoughts over some bottles of long-
unaccustomed champagne and regretted deeply that you
were not of the party. This fall a portfolio of 15 lithographs
will be issued by him which, I believe, will please you too.—
What are you up to, and when will you come? Are you
working well? How are the feelings of being a papa? What
do the grandparents say about this? And how is your
father, give him my most cordial regards.— I'm always
idiotically industrious, and I think you'll approve when you
come. So, hopefully, see you soon. Greetings also to all
from Quappi*

Your Beckmann

On May 25, 1947 Max and Quappi Beckmann were finally
allowed to leave Holland, "after eight years without leaving this
ironing board," as the painter noted. With delight they breathed
the fresh air and enjoyed the unaccustomed and yet so familiar
sights which Max had meanwhile often conjured up on canvas.
Paris, Nice, Monte Carlo, and Cap Martin were visited.

My name reappears in Beckmann's diary on April 11:
"Lackner wrote from New York about the triptych Blindman's
Buff. He'll come to Paris on the 17th."

The entry from Paris for Saturday, April 19, related:
"Bedbugs. Since I hadn't heard from Stephan yet, I caught him

101

later by taxi just when he started moving with his wife and child. Split-second exactness! Then in the Louvre."

I fetched Beckmann at the Louvre in the afternoon, and we sat down on the terrace of the Café de la Paix. He had become more earnest, less sarcastic, and seemed glad about the chance to speak his mind. "You can't believe what pressure has been removed from me since the nightmare has exploded!" he said, looking at me fixedly under arched eyebrows. We exchanged personal information and discovered our agreement about political developments.

On this afternoon Beckmann appeared not much changed, somewhat slimmed down of course, but at sixty-three still full of vital resiliency in spite of the golem-like mass of his figure. The dome of his forehead seemed lit up by flickering thoughts. His protruding chin had acquired a peasant-like quality, his wide, tight mouth was as expressive and impressive as always. Did I only imagine that his lips had adapted to the flat, prosaic Dutch intonation? The man no longer looked like a typical Berliner, that much was certain, and the ironic turns of speech from the "asphalt jungle" which he had sported in earlier decades had almost disappeared.

We dined, renewing old memories, at Prunier's seafood restaurant.

In the afternoon I drove Quappi and Max to our hotel so that our spouses could get acquainted. Beckmann scrutinized my wife with a painter's eyes and approved. Margaret told him about the very first "Beckmann" she had ever seen; it was in the Nazi "Degenerate Art" exhibition in Vienna, and though the circumstances were as inimical as possible she had been deeply impressed. Many years later she had been even more impressed to find this painting in my collection, and we had hung it in our house in Santa Barbara.

In our hotel room the two wives made perhaps too much ado about our first son—Peter was ten months old at the time—until Beckmann growled, "Well now, take this embryo away." My wife complied smilingly.

Seeing the city of my birth again was exciting for me, too, and in wonderfully adventurous spirits the four of us roamed the

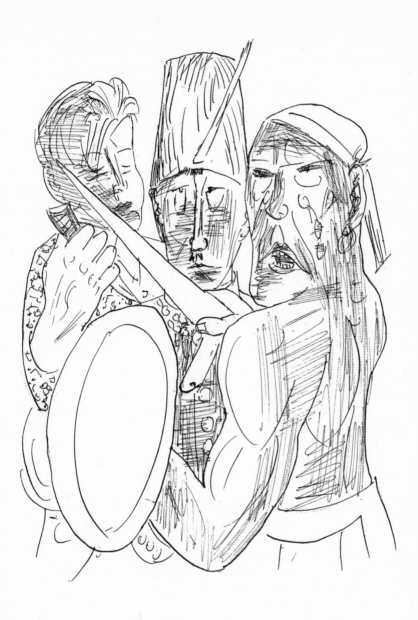

The Three Ruffians. Drawing from Goethe's "Faust." 1943

boulevards and Montmartre. My Packard, seven years old and quite inconspicuous in America, was a sensation in Paris, and the Beckmanns enjoyed the unaccustomed mobility.

We landed at the Bal Tabarin and drank the "noble champagne." The stage show seemed lively and exhililarating to me, but Beckmann remained somewhat critical. The girls, after years of rationed foodstuffs, were too slender for his taste: one knows, from his art, his predilection for fullblown female forms. During the cancan he remarked: "It does not steam yet as it should." Apart from this the evening was highly successful.

In Beckmann's diary that memorable April 20 is mirrored like this: "Slept late in the Hotel d'Arcade. Some cold wind. We ate wonderful Sauerkraut in the rue Royale expecting Stephan. He packarded along, and we drove to the Royal Monceau to his baby wife. Finally she came, still much theater around the baby, and we ate quite a good dinner in a restaurant near the Madeleine. His wife is a nice Austrian with blue eyes. Champagne. Then finally Tabarin on Montmartre, all this with Stephan, his wife and Quappi. Tabarin began beautifully, later altercation with a chauvinistic neighbor, but I did all right. Finally very hot and tired from yesterday. In Stephan's auto to the hotel."

The following day was dedicated to business with pictures. We went to the old brewery in the rue d'Anjou where, on the top floor, a former French girlfriend of mine had hidden many paintings, and she gave us a vivid account of the dangers and escapes under the Nazi occupation. Beckmann scrutinized each canvas singly and was very thoroughgoing. I promised to ship those which belonged to him to Curt Valentin's Gallery as fast as feasible.

Beckmann's diary describes this, under April 21, laconically:

"At three o'clock Stephan called for us, and we drove to a gigantic old house, up an elevator where in the uppermost heights many workshop paintings of mine were standing. Most of them belonging to Stephan, but "Self-portrait in white tie and tails" of 1937 and "Lady with Tambourin" reappeared and said, hello, Mister Beckmann. Then Stephan drove us to the Ritz, there we drank tea peacefully once again—then still the bar. Afterwards Stephan home to his baby and wife."

104

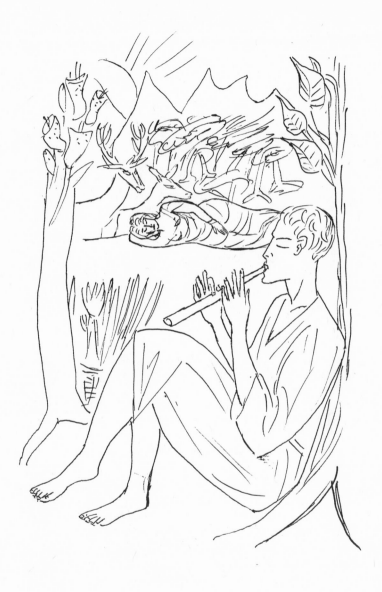

Flute-player. Drawing from Goethe's "Faust." 1943

Thus we separated. The two Beckmanns traveled to Amsterdam, the three Lackners to Ascona.

For more than ten years Beckmann had contemplated emigrating to America. His plans had miscarried for various petty reasons. Now he decided with utmost energy to live in the United States. It was his own free choice. Holland, after the liberation, suddenly took notice of him. The Stedelijk Museum bought his "Double-portrait" of 1941, which had been submitted many years earlier; the magazine *Centaur* published his London speech and his triptych "Temptation"; Dutch newspapers wrote about him. From Germany came offers of teaching positions; all kinds of honors combined to make the temptation a very real one. Beckmann remained politely aloof and furthered his projects to go to America.

On May 31, 1947, the diary registers: "Another piece of sensational news: Washington University St. Louis desires Mister Beckmann as a teacher. Hey, hold your horses so you won't stumble. I agreed by telegram, may God give that it turns out all right."

And so the next adventure of Beckmann's odyssey was initiated.

On September 8, 1947 he arrived in New York. "Veiled, sleepy giants stood in the wet mist on Manhattan." This first simile fascinated the painter immediately; it kept recurring in his art and writings during the remaining three years of his life.

The reception by the "establishment" was overwhelmingly friendly. His lack of English conversational skill did not matter; Quappi functioned as a warm-hearted and efficient interpreter from then on. On September 17 Max and Quappi traveled to St. Louis where Perry Rathbone—who had procured the job for Beckmann—received them and soon made them feel at home. A few days later Beckmann took over the master class of the School of Fine Arts of Washington University. This period of Beckmann's life is well documented in several American

publications. Here is how Beckmann described his new circumstances in a letter to me; I lived in Switzerland at the time.

St. Louis (Mo.)
Millbrook 6916
23 October 1947

Dear Lackner, thanks very much for the check of $500. I can use it well now with my various new expenses here. I'm glad that your book is being published, and I'm waiting for it. All else seems to be in good order with you, too.

Tya—well, one is here and, I must say, quite contented. St. Louis is lovely. A truly fabulous garden city with a hunk of downtown at the Mississippi, many skyscrapers like in New York. People quite agreeable, we are being spoiled a little because they all here have a very exact knowledge of my work. School not too strenuous. Very beautiful studio in which I'm working already energetically.— In short, it seems that life in its later stage has again a friendlier smile for me.— Too bad that you can't see the new Beckmann exhibition at Valentin's, November 17 to December 6, I would have liked to talk with you about my recent works. Well, this may still come.— America makes a big effort on my behalf. In November New York, January Chicago. March very big exposition St. Louis, further Boston, San Francisco, Museum of Modern Art and Basel—thus on and on.— I'm happy to sit here quietly where much reminds me of Frankfurt, general situation as well as circle of acquaintances. But more about this orally. It's still enormously hot here, it's hard to believe, remarkable as so many things here! Please give greetings to your dear wife and parents from both of us and let me hear again from you soon.

Always yours, Beckmann

In 1948 Beckmann went to Holland once again for three months; I was in Switzerland, and we did not meet that time. The purpose of his voyage was to obtain the final immigration visa to New York which would give him the right to acquire United

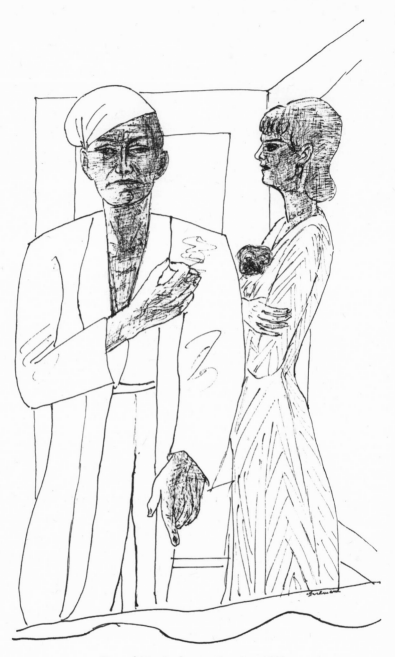

Mr. and Mrs. Beckmann. Drawing. 1944

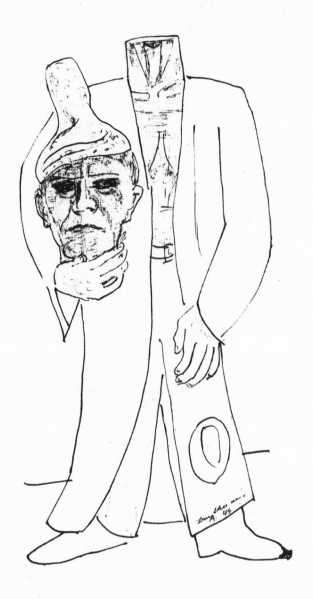

Beheaded self-portrait. Drawing.

States citizenship. This time the visa was granted without delay, and Beckmann triumphed: "Now I'm already a half-American."

Germany emitted all kinds of seductions: a book on Beckmann was being prepared in Munich, teaching positions were offered him in Frankfurt, Hamburg, and other places. His son Peter would have been delighted with a visit, but Beckmann resisted and left again in September "in an almost unbearable mood of liberation."

At that moment he renounced Europe. He left behind him the horrible memories of Nazi persecution, of war and occupation, the humiliations and the restrictions of his freedom. When he wrote: "adieu Europe" under that chapter of his life, Germany was included.

I have been asked many times in recent years—at openings of exhibitions in Germany, during encounters with his old friends, by journalists—whether it was only a coincidence that Beckmann never again set foot on German soil. I am sure this was in accord with his convictions. He represented an original facet of German spirituality which he could very well further on American soil. He told me last in 1950 that he considered only short future visits to the "fatherland."

Nevertheless, a German encyclopedia—Knaur's *Lexikon der modernen Kunst*—writes that Beckmann "made up his mind shortly before his death to take over his old teaching post in Frankfurt which had been offered to him." This misinformation keeps cropping up again and again in German articles on Beckmann. Though understandable from a psychological point of view, it simply is not correct. Beckmann had signed a permanent teaching contract with the Brooklyn Museum Art School. He loved America, and his last three years here probably were the happiest of his life.

Beckmann never faltered in his friendly interest in my literary activity. I profited much from his advice, criticism, and encouragement; insofar as a writer can learn from a painter for his own craft, I considered myself his pupil.

110

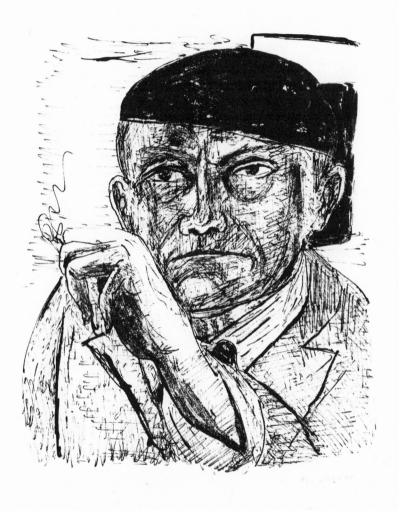

Self-portrait. Lithograph. From "Day and Dream." 1946

In 1949 I sent him my new play "Doomsday minus One" which crystallized my experience of fighting Hitler's Germany while my wife's brother was serving in Hitler's *Wehrmacht*. Beckmann praised the style and concentration and found "much of it really excellent." The play was premiered in Vienna in 1950 and later produced in several theaters in West and East Germany. I reported to Beckmann on the Vienna premiere and received the following answer:

> *234 East 19th Street, New York, 31 March 1950*
> *Dear Lackner, thanks for your letter of March 21. I'm especially glad that your play's performance was successful since this confirms my own earlier judgment which I wrote to your father. Of course I am glad for your sake because you urgently needed some success. So—please continue!*
> *This summer I'll be instructor at Mills College for six weeks. Alfred Neumeyer, the art professor there, wishes to exhibit the paintings from the collections of Lackner, Morgenroth and Wright Ludington at the college. He asked me to write to you so that you'll support this thing. Probably I'll come to Europe for three weeks late this summer, but I'll be so busy that I won't be able to get to Switzerland.— How about you looking over America again? If one is successful it is quite amusing here.— Just now I'll be traveling to Bloomington, Indiana to portray a couple with six children—oh my God—well, it will turn out all right.*
> *Please continue to let me hear from you*
> > *Yours, Beckmann*
> *Regards to your wife, also from Quappi.*

While his pictures were hanging in the Mills College exhibition in Oakland, Beckmann signed a number of them, according to my wishes. He misdated a few, due to lapses of memory. Some of them had been signed in the old German or gothic handwriting: these signatures he overpainted now and re-signed them in Roman characters, to make them more readable and, perhaps, because his feelings had become more internationalized.

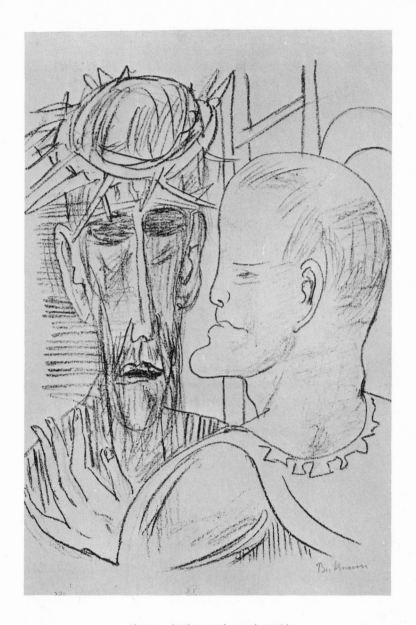

Christ and Pilate. Lithograph. 1946

On July 15, 1950, Beckmann wrote his last letter to my father: "The exhibition turned out really well, and Neumeyer and myself are harvesting all kinds of accolades. You probably have seen Ernst's beautiful essay used as a foreword."

The following are some paragraphs from my introduction to the Mills College show.

"Beckmann has continued to develop according to his own law. He still has that seemingly uninhibited way of using his brush with the utmost vigor, this sometimes almost terrifying subjectivity; he still uses his own shorthand to catch the fleeting visions of his eye and of his brain, not paying attention to pretty details. There is an overwhelming strength in every stroke.

The Germans, blinded by Hitler's doctrines, never knew how typically German Beckmann really is. In painting, he is what Nietzsche was in philosophy: saying yes to life even in its horrible aspects.

The horrors of war and suppression were nothing new to his art: ever since he had been a medic in the First World War, mangled and tortured bodies had always held a place in the panorama of his world, side by side with the joys of the good life. His painting embraced all the facets of modern life among machines or luxuries; it showed prehistoric idols in one frame together with medieval rulers and contemporary flapper-girls or farmers or business men. And this variety of forms was always subordinated to one purpose: banishing ancient fears by visualizing them. This gave a unity of style to his overflowing fantasies.

And so, the Second World War was not an interruption in the growth of Beckmann's art. Against the background of that terrible experience, the glowing colors of his new landscapes are even more touching. These bright and gay scenes, seen through an eye which has witnessed despair and destruction, are really a credo: a confession of love to life which is sometimes so sad and sometimes so wonderful."

114

Beckmann's three American years brought him more acknowledgment than many other deserving artists experience during a lifetime. The late success appeared to Beckmann as a kind of "war reparation" which the world rightly owed him; a more or less metaphysical feeling which had nothing to do with cheap self-glorification. The honors bestowed on him only confirmed the important role which art had to play in the world, and so he accepted them with graceful satisfaction: the First Carnegie Prize for Painting in the United States, the honorary doctorate at Washington University in St. Louis, the one-man show at the German pavilion and first prize at the Venice Biennale. His creative activity remained more important to him than any outward success, and he never thought that laurels could be used as a restful pillow.

I visited Beckmann for the last time in New York, two months before his death.

After our arrival, my wife and I drove to his old address, way downtown on 19th Street. A wrinkled, gray lady opened the door and told us that those boarders had been part of a world conspiracy, that they distributed secret messages every night by rays and waves which she received in her inner ear and which prevented her from sleeping; so she had sent them packing. We fled the conspiratorial, hoarse chatter—it was a thoroughly Beckmannesque scene. Valentin gave us the Beckmanns' new address, 38 West 69th Street, where they had found a roomy apartment on the first floor, quite close to Central Park.

Beckmann's diary of October 14, 1950, registers this observation of a painterly eye: "In the afternoon Ernst came here from Ascona, with a deep tan and somewhat heavier."

Following an old habit, Beckmann and I drank coffee in a hotel lobby, and that this time it was in the Plaza in New York seemed just a slight change of scenery on the stage of our lives. Beckmann's English had become serviceable enough. He enjoyed being polyglot when he interspersed his German-English with Spanish "Quien sabe" and French "O mon Dieu." We promenaded along Fifth Avenue, looked at elegant window displays, crossed the lovely square with the fountain to Central

115

Park South, smiled at the horses and high-hatted buggy drivers between skyscrapers; the plane trees displayed the golden hues of autumn. Beckmann maintained that "good old New York" had already become "his" town.

He related with a trace of a grin that *Time* magazine called him habitually "the man with a rainbow in his pocket," and he opened his coat pocket for a quick, curious glance.

The next day, my wife and I were invited for lunch at the Beckmanns in the narrow 69th Street flat. While Frau Quappi prepared food in the kitchen, Max ushered us into his studio. The light from the outside was very dim, but Beckmann had a strong neon daylight fixture installed in the center of the stucco ceiling, which made it possible for him to paint late in the evening. We were surprised that he let us see pictures which he considered still unfinished: "Backstage" and his last triptych, "Argonauts." The "Argonauts" already looked thoroughly organized with a balanced scheme of lovely colors, but Beckmann declared that he was not yet satisfied. I seem to remember that the bearded oldster—who now climbs up a ladder from the sea—was then kneeling on the shore, which gave him a strangely touching, humble character. Of course his definite gesture directing the youths to the big journey is an improvement, but I also liked the earlier version.

The effect was even more overwhelming because the painter had never let people glimpse his work in progress. Did he have a premonition which made the showing more urgent?

I found a certain poignancy in the fact that the argonauts' journey started under the auspices of a darkened sun: a purple-black disk produces an eery eclipse. This motif was a reprise of early themes, the eclipsed sun appeared in Beckmann's "Resurrection" of 1916 and in the "Deposition" of 1917; it actually goes back to a much earlier impression, to the eclipse of both moon and sun in the "Crucifixion" by the half-mad Renaissance master Maeleskirchener, whom Beckmann had chosen as a model in his youth. This rounding-out of a career, this recapitulation as in a sonata, had something final, and though I did not consciously grasp it, I felt a slight shudder.

The day before I had found that Beckmann looked tired and

116

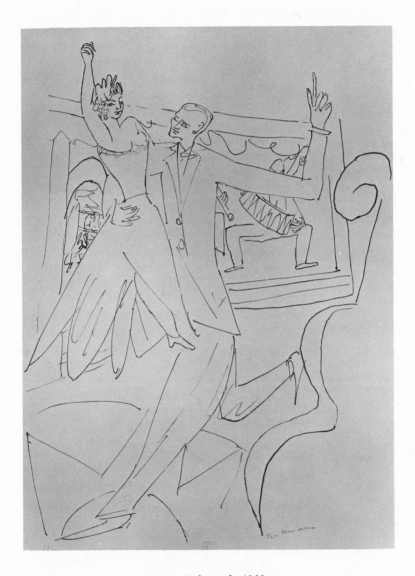

Tango. Lithograph. 1946

somewhat sick, but my wife's presence seemed to refresh him, and she dispelled my apprehensions.

Quappi was an excellent cook. The luncheon hour passed in a friendly mood with memories and plans for the future. The next day we drove on to California.

There was some message in the "Argonauts" which pursued me for a while and which I could not quite make out. I was sure that it was Beckmann's most mature, most self-contained work. The lightening of the burden was obvious: there was no pain, no torture in the subject matter. The eight earlier triptychs had relied on shackled and mutilated prisoners to heighten, by contrast, the elation of some luckier personages. Now complexes and complications had disappeared; the artist did not have to fight his own conscience or atone for the guilt of his times. Instead of the customary old blaring gramophone funnels, raucous trumpets, and carnivalistic noisemakers, Beckmann had used noble lutes and harps to accompany his new pageant. Everything in the "Argonauts" pointed to harmony and far-reaching enterprise. Wasn't this, somehow, a new beginning?

In analyzing this triptych one did not get much help from the traditional categories of the art historians. I thought back to my first impression of "Man and Woman" of 1932, which seemed to inaugurate a neoclassical period, and to the "Self-portrait with the Horn" of 1938, which created a romantic ambiance. Now, in 1950, classical and romantic elements were fused in a new synthesis, augmented by expressionist decisiveness. The result was a timeless composition fulfilling its own laws.

Beckmann himself must have observed his personal development quite clearly. How proudly he had proclaimed himself a modernist in 1926! He wrote to J. B. Neumann: "I'm absolutely conscious of the fact that, at the moment, I'm standing at the most radical end of the development of painting, and that's (probably) where I'll always be."

But striving for the latest fashion became abhorrent to him as time went by. In 1938 he had recommended to me the "retreat

118

A Dream of War. Lithograph. 1946

from the whirl of shadows" ("Ausscheiden aus dem Getriebe der Schatten"). Toward the end of 1950 this aim was being reached, in a double sense.

The definitions of aesthetics, meant to be scientifically exact, usually rely on the concepts of classicism, romanticism, and the numerous ensuing "-isms," but they don't seem to circumscribe the essence of art. Even the most exact definition can only serve its writer to nail down a certain work as falling into the class of works of art, giving it the value and the aura of art which the writer already had experienced in the first place. It always continues defining in circles, and it lasts only as long as the taste of a certain period remains in force—and this might be only a very short span of time. It would be more fruitful to discard all aesthetic definitions and postulates and to surrender to the occasional, overwhelming experience of art. There are no rational rules to magic; yet magic is the common denominator of all deeply gripping artistic endeavors, from the hunter's magical image of a bison in a prehistoric cave to the "charming," i.e., magic, sketch of a modish lady by Manet. The mammoth, by dint of being caught or killed in a painting, is subjected to the hunter's will. The tortured victim of the twentieth century on Beckmann's canvas is, thereby, subject to the artist's reformatory zeal. In this sense, Beckmann's works also have a magician's touch, they all are located somewhere on the scale between charm and magic: between the charming, shimmering surface of life and the magic nucleus of philosophical essence.

None of us, not even the best artist, can progress to the knowledge of Kant's *Ding an sich,* of the thing as such, independently of a beholder. Even color photography does not reproduce reality, because a photograph, in turn, has to be viewed by subjective eyes and filtered again through the personality of the recipient. And no work of art transmits directly what the artist has experienced. Each of us dreams his own dream, irrevocably shut up inside the glassy kaleidoscope of his five senses. This kaleidoscope magically represents the world, but there is no way of checking whether your world is my world, and vice versa. The great artist's imagery is more convincing, more seductive, but the multicolored veil of Maja remains impenetrable.

This subjectivity is what makes great art so fascinating. Beck-

mann's painted dramas of heroes and monsters are not much more illusory than, for instance, the color blue, which, to our visual nerves and brain, stands for electromagnetic waves of a certain length, but they give more insight into the human psyche than a blue square. A very personal world view is usually thought to be "wrong" by many contemporaries: it appears biased, seen from an off-center point of view, and therefore distorted. Later on even the average viewer adjusts to the new slant, adapts to the "ex-centric" perspective, and enjoys the communication with a powerful, subjective personality.

"Ça dure vingt ans," Ambroise Vollard used to say when his beloved impressionists were mocked and rejected: twenty years of incomprehension seemed normal to him. The case of Beckmann was dragged even longer through the courts of official taste and public opinion. But his magic keeps spreading.

M y wife and I had hardly finished hanging some of our most beloved Beckmann paintings on Californian walls when we received a telegram from New York: "MAX DIED SUDDENLY OF HEART ATTACK TODAY. QUAPPI BECKMANN."

It happened on December 27, 1950. His son Peter, the physician, believes that it may have been a cerebral hemorrhage.

Quappi told me much later, when her grief had become somewhat contained, about the last days of her husband's life. We were sitting in front of the "Argonauts," and Quappi pointed to the head of the youth on the right side of the center panel: his blond hair seems to be blown toward the stars.

"This head was already there before Christmas, but he kept on correcting and improving it even though he felt so terribly tired. Then he promised me not to work during Christmas week. He did not feel the usual pain in his chest, only this terrible tiredness.

"I had asked his woman doctor about some pills, and she phoned on Saturday morning at eleven o'clock.

"She said, 'Is your husband in the room with you? ' 'Yes.'

"I was very worried, but I pulled myself together so that he wouldn't grow suspicious.

121

"I heard her say over the phone: 'Your husband has a severely damaged heart, the end may come at any time.'

"Max became attentive, but I said as calmly as possible into the telephone: 'So you think he is getting better?'

" 'I don't want to worry you unduly, but you must know about his condition.'

"What about his smoking? I asked. 'There is no sense any more in depriving him of this pleasure,' she replied.

"Max grew restless, and I told him: 'Everything is all right, you may smoke.'

"The doctor recommended that Max should not swim and avoid mounting stairs; I should watch out for him but not let him know how bad his health really was.

"The evening before," Quappi continued her tale, "Max had started painting a new still life, but he controlled his creative impulse and renounced work. Unfortunately it was snowing hard. Max couldn't leave the house for long and grew very nervous. And at eight o'clock that evening he started painting again. I broke out in tears and locked myself in the bathroom."

The last entry in Max Beckmann's diary reads: "Quappi was angry—"

Quappi continued her report: "The last thing he did that evening was that he brushed these ghostly yellow lights over the skin of this youth, in very thin washes. Then he came into the living room, pale and sweaty. 'Well, now I won't do a single brush stroke any more.'

"At hearing this sentence I had a strangling feeling in my throat. Max mumbled: 'I feel like a squeezed-out lemon,' and went to bed.

"On December 27, at ten o'clock in the morning, our tax consultant came, and Max, quite relaxed, drank coffee with him while talking about finances. Usually he didn't want to talk before breakfast, but on that day he was loquacious. 'I feel marvelously well today,' Max said. The tax man explained that we would not have to pay too high an amount, and in my pleasure I did a few dancing steps."

A little later Max wanted to take a stroll.

Quappi reminded him: "Don't forget to be back for lunch at half past twelve. Where do you want to go?"

"Into the park, perhaps over to the Metropolitan Museum."

"Are you warm enough?"

"Yes, I'm wearing my shawl."

Quappi put Butshi, the Pekinese, on the leash; the giant man and the minuscule dog took off together into the snow.

Only a few moments later the bell rang, the janitor appeared with an ashen face, behind him two policemen.

"Mrs. Beckmann?" asked the first policeman.

"Yes?"

"Your husband has just died."

This occurred at the corner of 69th Street and Central Park West. A doctor, who was called immediately, could only pronounce him dead.

Several days after Quappi's telegram a letter from Beckmann reached me, like a voice from beyond the grave. It was an especially beautiful letter; I was deeply touched that he still reviewed a book of mine, *Das Lied des Pechvogels,* which I had sent him. Very moving is the resignation: "Na nun hab ich's hinter mir. Puh—"

This was Max Beckmann's last letter.

Dear Stephan Lackner, thank you for the Christmas greetings and, somewhat belatedly, for your "Song of the Blackbird." The latter has pleased me very much and also awakened many memories of Frankfurt. A few somewhat conventional expressions bothered me a little at the beginning— "his profile was like a Greek cameo" —but the voyage to Berlin and the very beautiful surprise ending make the little book ingratiating.— Have you read "The Lady is not for burning" by Christopher Fry? It was staged here successfully, has some very good moments as far as language and philosophy are concerned, but the glued-on happy ending is rather painful.— What are you doing in peaceful Santa Barbara—children and literature?

Yesterday I finished a new triptych, therefore I'm pretty well squeezed out. It was a damned lot of work, and

123

Letter of December 25, 1950

25. 12. 50. New York

Ich habe gestern mein neues Tryptichon beendet und bin daher ziemlich ausgelaugt. Es war eine verdammte Arbeit und viele Tage wußte ich nicht wo mir der Kopf steht oder fällt — Na nun hab ich's hinter mir. — Tuh — — —

Ende Februar habe ich bei Curt Valentin eine große one man Schau. — Das würde Dich vielleicht interessiren —

Hier schneit's u. die Stimung ist depressiv. Aber das sind wir gewohnt und hindert nicht am Arbeiten — Hoffentlich geht es den Eltern gut bitte ihnen doch unsere besten Wünsche zum Neujahr zu übermitteln und laßen Sie ab und zu was von sich hören freue mich immer Ihr

Beckmann

Grüße auch an Dr. Gabbin(?)

Letter of December 25, 1950, continued

through many days I didn't know whether my head was still up there or falling down. Well, now I have it behind me. Puh—End of February I'll have a large one-man show at Curt Valentin's. This might perhaps interest you—

Here it is snowing and the mood is depressive. But we are accustomed to this and not prevented from working. I hope your parents are well, please convey best New Year's wishes to them. And let me hear from you occasionally, it always gives me joy.

Yours, Beckmann

Regards also to your wife!

A few nights later I saw him walking over a blue-gray expanse. He looked into his coat pocket and said with a faint, sad grin: "Seems I have a rainbow in my pocket." And I saw the rainbow emerging and flowing all across the sky.

Olive Branch. Drawing from Goethe's "Faust." 1943